·FILL YOUR· WATERCOLORS WITH LIGHT AND COLOR

ROLAND ROYCRAFT

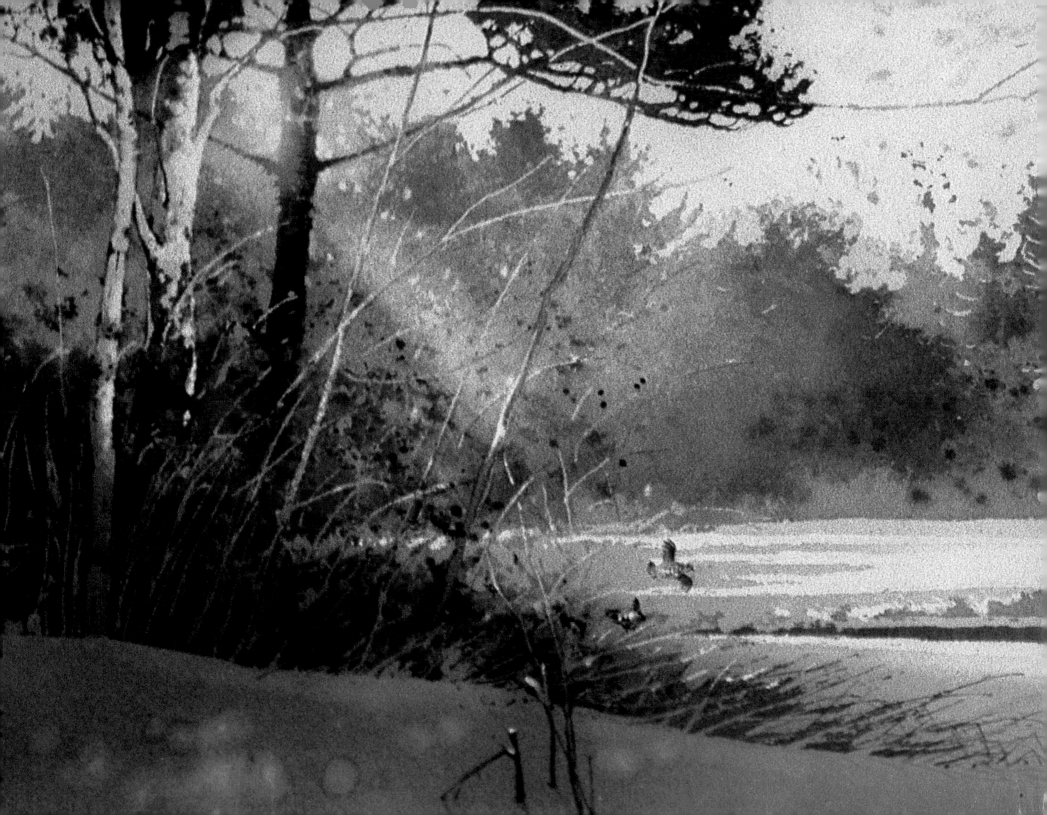

· FILL YOUR ·
WATERCOLORS
WITH
LIGHT
AND
COLOR

ROLAND ROYCRAFT

NORTH LIGHT BOOKS

CINCINNATI, OHIO

Fill Your Watercolors with Light and Color. Copyright © 1990 by Roland Roycraft. Printed and bound in Hong Kong. All rights reserved. No part of this book may be reproduced in any form or by any electronic or mechanical means including information storage and retrieval systems without permission in writing from the publisher, except by a reviewer, who may quote brief passages in a review. Published by North Light Books, an imprint of F&W Publications, Inc., 1507 Dana Avenue, Cincinnati, Ohio 45207. First edition.

94 93 92 91 90 5 4 3 2 1

Library of Congress Cataloging in Publication Data

Roycraft, Roland.
 Fill your watercolors with light and color / Roland Roycraft.
 p. cm.
 ISBN 0-89134-338-5
 1. Watercolor painting—Technique. I. Title
ND2420.R69 1990
751.42'2—dc20 89-26600
 CIP

Dedication

My heartfelt thanks to those who have aided me in this book, the most exciting project I have ever undertaken:

...to Dorothy Christine Roycraft, my wife and counselor, who spent countless hours typing and retyping the manuscript to its final moments.

...to Bonnie Silverstein and Mary Cropper, whose insight and understanding turned my many thoughts and works into a teaching experience.

...and to the many others who designed the physical appearance of this book.

In Memoriam

I would like to dedicate this book to my good friend Bee Sloan, whose enthusiasm and confidence in me made this work possible. I am sorry she could not have lived to see its completion.

Contents

The Artist's Creed

The challenge of the moment with its ever-changing moods, the spectrum of nature with its diversity of subject, and the presence of something beautiful that only God can create all lend to the atmosphere that surrounds us as we walk through the paths of life. These are the things we try to stop for one fleeting moment with a spontaneous splash of color and a direction of line. They are the pictures in the mirror of time—called watercolors!

The search to find oneself and picking the medium and style to fulfill your innermost feelings is the task that every artist has. I've chosen transparent watercolor from among other mediums because it suits my personality best. Watercolors are free-flowing and spontaneous in character. The accidents that happen when paint touches water give an expression other mediums can't accomplish, with an individuality and results far beyond your fondest expectations. Watercolor represents the free-spirited individual who likes surprises and responds in an instant like the seed of a thistle in the wind.

Introduction

The Creative Environment

I am intrigued by the beauty of nature and the many wonderful ways in which it expresses itself. And nature is also the major influence on my painting philosophy and the techniques I have developed. I believe that all artists should surround themselves with the things they enjoy to aid the development of their creativity.

I laid the basis for my present work, much of which is intuitive and abstract in concept through endless years of roaming the countryside observing, memorizing, and sketching everything nature has to offer. Even though most of my present work is done in the studio, there is still no substitute for on-location painting to learn the basics.

I'd like to share the knowledge and techniques I've learned to help you to render your own environ-ment. If you just look around you, you'll find that there's excitement everywhere. Capture those experi-ences on paper before they get away. The struggle goes on forever, but the rewards are ever-increasing.

Learning to see is the most impor-tant sense an artist can develop. Seeing involves much more than just sight. It includes becoming aware of the abstract patterns formed by light and dark values, seeing the illusions of space and form created by color and perspec-tive, experiencing the emotional impact resulting from the smells and sounds present. You must be able to feel the presence of the situation and use every tool possible to convey its message. But it takes patience to absorb the qualities of a situation, especially if there are outside distractions. Every effort should be made to memorize the effects of light (atmosphere) on an object as well as to see how it is made. This awareness will aid you in developing your intuitive abilities.

Learning to act means developing a program for personal artistic devel-opment and broadening your horizons toward that fulfillment. By stimulating your creative abilities, you can raise yourself up the ladder of accomplishment. When you learn something new, you are elated. But as you practice that skill you become satisfied, and you stop learning. This is a plateau. Only dissatisfaction stimulates renewed effort to rise again, to work at climbing the stairs of success.

Learning to enjoy painting is part of the personal fulfillment you can find in your art. Relax while you work and appreciate the interpreta-tions found in each brush stroke. Stand back occasionally to analyze the effects of color and the relation-ship of the various elements. Your individual style will develop with time just like your own handwriting. The secret is...have fun!

Studio and Materials

You should have a separate area set aside in which to do your painting, which encourages you to develop a regular painting routine. Surround yourself with good work, books, and reference material to make it as easy as possible to always do your best.

Over the years since I first entered art school I've collected an assortment of brushes, tools, gadgets, and other accessories. Gradually everyone settles on a few items that he or she can't get along without. Here are some of mine.

1. Paper. A good rag paper is the most important of all materials. I use 140-pound Arches cold-pressed paper almost exclusively. Arches is tough enough to take Maskoid and the lifting of color plus knifework where necessary, but is not as white as some other papers. To stretch it I soak it about five minutes in water, then staple it to a 3/8 inch thick piece of plywood and let it dry. I tape the edges with white masking tape, which acts like a mat during the painting process.

For smaller paintings—one-quarter sheet or less, for outdoor sketches and such—I wet the paper on both sides with a natural sponge, smack it down on a Formica surface board, and immediately start to paint. When the painting is about three-quarters finished and starts to get dry, the paper is stapled to the board for completion. This saves all the extra drying time.

2. Palette. I've used many kinds of palettes, but I prefer a large butcher's tray, because it gives me more room to mix my colors freely. I use two sets of primaries: a cool set of Winsor red, Winsor yellow, and cobalt blue; and a warm set of cadmium scarlet, aureolin yellow, and Antwerp blue. I also use French ultramarine blue, cerulean blue, brown madder and Payne's gray.

3. Brushes. I have an assortment of rounds from #2 up to #20, flats from one-half inch up to two inches, filberts #8, #10, and #12, plus an assortment of Chinese hake brushes. I also use a couple of worn-out oil brushes and an old toothbrush for scrubbing out.

The most important thing to consider is the relationship between the size of the painting surface of the brush (flat versus round) and the size of the reservoir that holds the paint supply. This controls the amount of water with pigment that enters the paper. The round brush is pointed for entering small places, yet there's potential for releasing too much liquid and getting back runs because the brush has a large reservoir in the bulb above for holding paint. The flat brush has a wide painting surface in relation to the reservoir area, so less liquid is released while you're painting. A rigger has long bristles in order to hold more paint for a long, thin line. It's good for grasses and other sweeping type lines. The filbert brush is essentially a flat brush with a round end instead of a flat end. I use it in creating loose vegetation in direct painting.

4. Tools. A mat knife, nail clipper and razor blade are useful for scraping. At times I also resort to a spray bottle of water, water jar, electric eraser, masking fluid, salt,

rubber cement pick up, staple gun, palette knife, sponges, and tissues for mopping up. Sticks, fingernails, blotting tissue and the artist's imagination all help.

5. Matting. I preserve all my painting with rag museum quality mat board backed with foam core and frame them under glass.

6. The Studio Equipment. My working surface consists of two drawing tables and a taboret arranged in a u-shape. I always stand while working so I use a table high enough that I don't have to stoop over. An incandescent light hangs over each table.

I work on a 72x30 table. The shelves below hold my watercolor paper and mat board. I own a 30-inch paper cutter and a mat cutter. I occasionally use an opaque projector to blow up a thumbnail sketch while retaining its proportions when enlarging it to watercolor paper size.

I like classical music and find that playing it adds to the studio environment and often sparks my creativity. A filing cabinet and reference books round out my studio.

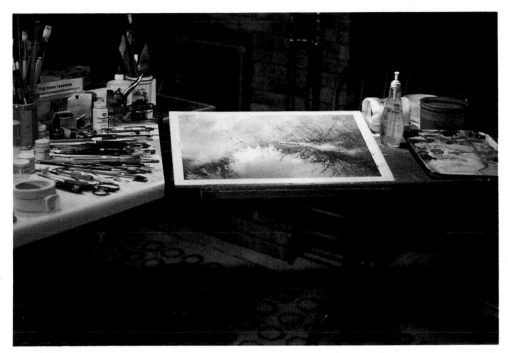

Here's my working area, set up the way that's best for me.

DIRECT PAINTING

*Working with
a brush*

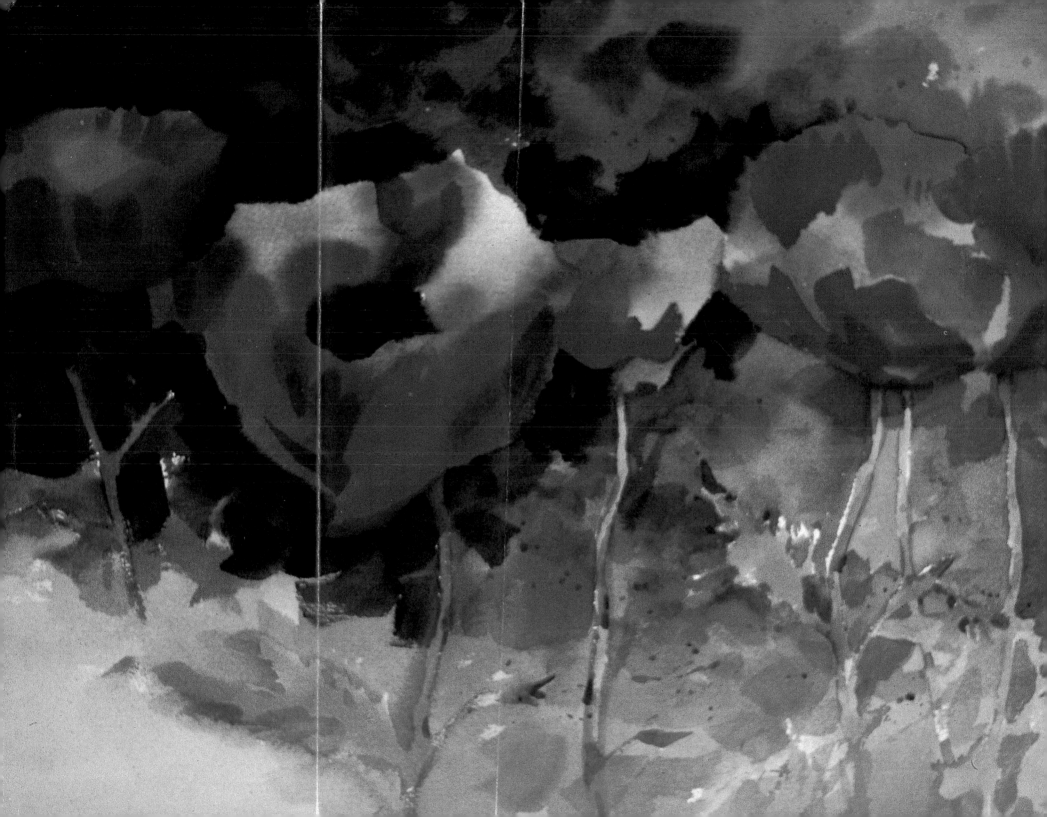

Expressing Feelings in Paint

Watercolor is the perfect medium for expressing your emotions because it's so free-flowing and spontaneous. Watercolors have an individuality and excitement of their own that can produce results far beyond your fondest expectations. You can invite unusual results by throwing paint, spattering, pouring, and misting once the paint is on the paper. Watercolor is for the free-spirited individual who likes surprises. My own technique, which I call *intuitive painting*, uses watercolor's uncontrolled happenings to the fullest. For me, this is what makes painting exciting. It's letting the painting paint itself.

An intuitive painting usually starts out as abstract forms, capturing a mood or atmosphere rather than a specific subject. As the pigment reacts with water on the paper, various happenings occur that suggest further applications of color. To work intuitively as an artist, you must learn to respond quickly to keep up with these events. At some point the painting may start to take on a realistic quality. Yet it will still have a vitality of its own that you couldn't get by starting with a representational approach.

I begin an intuitive painting by the seat of my pants—without knowing what I'm going to paint. I usually start with what will become the sky area because the sky is the most atmospheric element. It sets the mood and feeling for the entire painting; its color and value control what follows. For example, a dark sky area (actually a medium value) prepares the way for a lighter value on the land in the middle bar, which will probably evolve into snow or sand. A light sky, on the other hand, sets the scene for a middle value or dark land mass, probably a summer scene. The rest of the subject matter just develops.

When I paint intuitively, I keep playing with the shapes until they start to suggest something. Then I put in the realistic details such as trees or whatever comes to mind.

Sunset Surf (14x10). *Intuitive painting of the waves smashing on the rocky shore of Lake Superior. This spontaneous painting on Strathmore board took only about twenty minutes.*

On the Edge I (19x14). *I use a simple, abstract foundation when I paint intuitively. Despite its abstract basis, this painting still looks realistic.*

Direct Painting

I use two different methods of painting: direct and indirect. I do direct painting with a brush, while indirect painting is done by pouring and masking.

In direct painting, I work directly on the paper with no penciling. I rapidly brush in the large expanses—earth and sky—with large brushes and add details (darks) as the paper dries. This method gives a combination of soft and hard edges, color gradation, and spontaneous effects in technique. I either start with the lights and work toward the darks or aim for the final effect in a single stroke with as few over-paintings as possible.

To improve your direct painting, remember these points:

1. Speed. If you work too slowly and try to stay inside prepenciled areas, you get a paint-by-number look. Don't pencil in any painting until you feel comfortable drawing with a paint brush.

2. Wet-in-Wet. Mix colors on the paper by applying one color next to

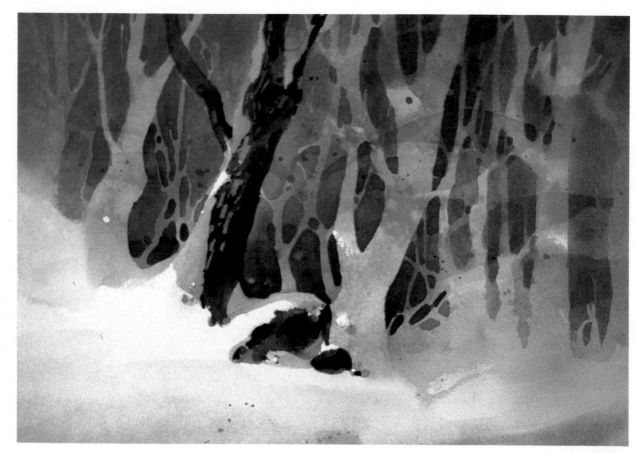

Waiting for Spring (14x10). Odd as it may sound, the colors of the woods in winter are basically warm, so I began this direct painting with the warm primaries—aureolin yellow, cadmium scarlet, and Antwerp blue. I used the cool primaries—cobalt blue, Winsor yellow, and Winsor red—only for atmosphere. I also modeled the snow with the cool primaries to give it a light and airy feeling.

another rather than mixing on your palette. The colors should overlap slightly and bleed into one another. Work fast so the first color doesn't dry before the next is laid down. You can rewet the paper before applying the next color to get an even softer result.

3. Changing Colors. To add variety to an area, use several slightly different colors. If you paint an entire area with only one hue, you'll get a flat, poster-like appearance.

4. Wrong Values. Incorrect values, often on the timid or weak side, are the result of inexperience. It's better to have used too strong a color. You can lift a too-strong color without damaging its freshness, but painting over a too-weak color to strengthen it results in a dull, over-worked look.

5. Paint Progressively. Finish each part of a painting before moving on to the next. Your work should be fresh, full value, and spontaneous.

Reflections (21x14). *I painted this on soft paper, so I couldn't mask anything; everything was painted directly. I ended up doing some pouring (indirect painting) in the lower left corner of this one where I'd painted individual leaves that looked spotty. I poured dark blues over them to unify the values and accidentally poured some blue over the flowers, making one of them blue. The pouring softened the painting and deepened the background.*

Positive/Negative Painting

Since you don't use white paint to cover or tint other colors in transparent watercolor, you must consider the white of the paper carefully. As you paint, the white of the paper disappears and can't always be recovered. In other words, you don't use white, you *lose* white. Sometimes you can scrub or lift to bring back white, but other times it may be gone for good.

To preserve the white of the paper, you'll often find it's necessary to paint the negative shape of the object—putting color everywhere else in the background *except* where you want your shape. The background space around an object is the negative space, and the object itself is the positive form. So you must train yourself to think of form and space, positive and negative.

Every time you see a white or light-colored object, think about how you would paint the space around it. That space might include other objects, a dark wall or background,

perhaps a dark sky. Once you understand how painting negative space creates positive form, you'll have learned one of the most difficult but essential elements of watercolor painting.

To help you think in terms of negative/positive painting, I've devised two painting exercises: the first is simple, the second is a more sophisticated painting of the same subject. The simpler version concentrates on the basic techniques; the advanced shows how you can use those techniques to create many interesting variations on a theme. The interesting textures in the backgrounds of the more sophisticated version are somewhat complicated to create. Be sure you have a good grasp of the basic techniques before you try the more advanced.

This negative photograph is an example of thinking in reverse when painting around objects. Negative painting is probably the hardest skill the beginner must master, but it's absolutely essential.

10

Winter Woods (14x10). *Here I painted one tree as a positive shape, then did the background trees with negative painting. Look at the first layer of a negative painting and see what areas you can work around or darken. Picture shapes in your mind and work to bring them out.*

Exercise 1: Simplified Version of Tulips

I'll begin by doing the tulips with the warm primaries—aureolin yellow, cadmium scarlet, and Antwerp blue. These have more covering power, but you'll get mud if you paint over them. I'll use the cool primaries—Winsor red, Winsor yellow, and cobalt blue, considerably thinned with water—for the background. These cool colors give you a more delicate color than the warm primaries and make a nice background. The background color is very transparent, and you can glaze over it without its getting muddy. Don't be too precise when doing your first negative wash. This is your chance to be sloppy; interesting effects can be obtained by not being too careful at this point.

Step 1. *Let's begin with the tulip, a single, positive shape. I use aureolin yellow and cadmium scarlet for the flower (the warm primaries) and a combination of Antwerp blue and aureolin yellow for the leaves and stem.*

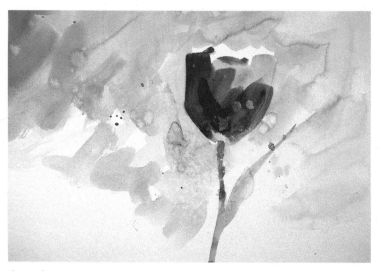

Step 2. *I use Winsor red, Winsor yellow, and cobalt blue, thinned considerably with water, for the background. These colors will produce a nice transparent background and can be glazed over without becoming muddy.*

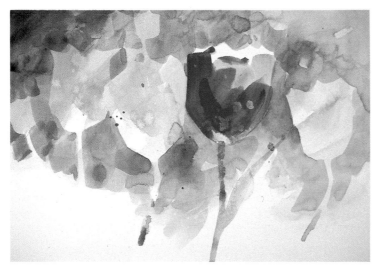

Step 3. *I painted the first tulip positively. Now I do several tulips by working negatively around their shapes. I do this by putting color around them to define their shapes, using the same transparent colors as in the last step.*

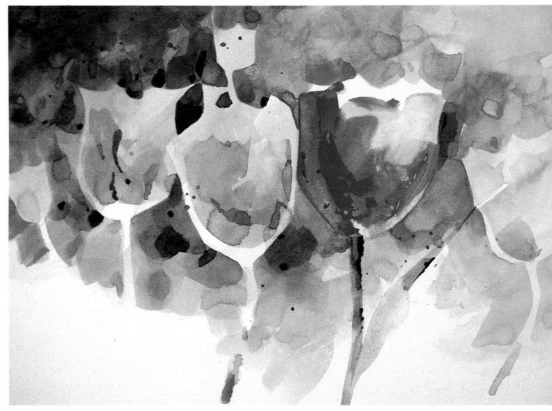

Spring Goblets (14x10). *In this last step I use the more opaque warm primaries again. I chose the warm primaries because I want to increase the contrast between the shadows and the tulip shapes. I can use these stronger colors because I won't be painting on top of this final wash again. When the background is completely dry, I run a second, deeper wash of the cool primaries to further delineate the tulip shapes and add more punch to the painting. Cobalt blue doesn't make a good green, so I use the Antwerp blue instead.*

Exercise 2: Advanced Version of Tulips

I painted this version on 140-pound Arches paper. Since the paper could take more abuse, I was able to lift colors out to soften some of the edges and could work more detail into the painting. This should suggest the range of what you can do using the same basic technique.

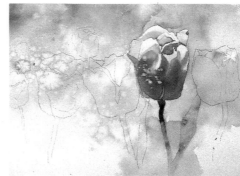

Step 2. *I let the loose, semi-opaque washes of the background flow right over the stems.*

Step 1. *First, I paint the positive shape of the tulip using warm, opaque colors—aureolin yellow and cadmium scarlet, with a touch of cobalt blue. The stems are aureolin yellow and Antwerp blue.*

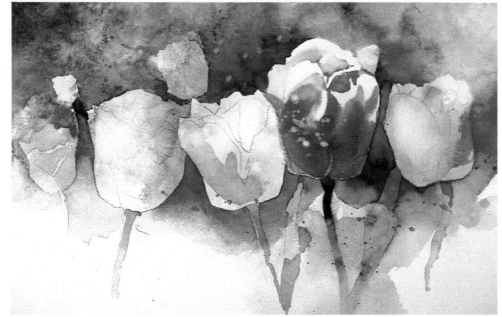

Step 3. *I paint the next two tulips as negative shapes, repainting the background wash over everything except where the tulips will be. This automatically creates a sense of distance by making the second group of tulips a middle value. Then I add four more tulips with negative painting, again repainting the background wash over everything except where those tulips will be. Notice how much darker the background gets.*

14

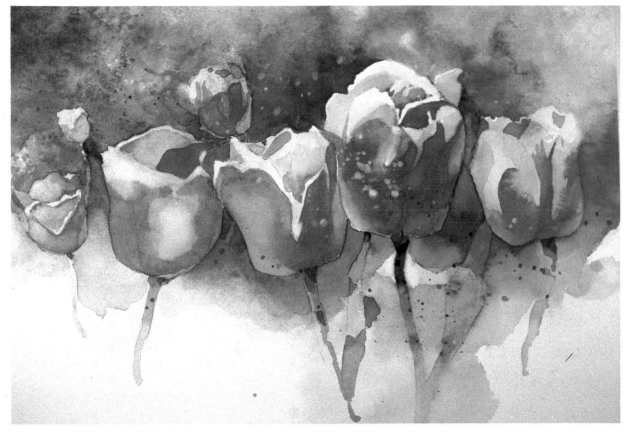

Seven Tulips (14x10). *Now I need to add details and strengthen weak areas, particularly within the tulips. The last glaze of cool primaries sets off the flowers. I also add detail to the shadows in the background tulips and petals with aureolin yellow and cadmium scarlet.*

Painting Details

Many paintings in this book use small figures (fishermen, skiers, hikers) to focus the viewer's eye.

I penciled in the fisherman for *The Coho Run* as part of my initial drawing. Then I masked out that area and other details before I began painting so I wouldn't have to worry about them while painting. If you're constantly worrying about leaving whites for details, you can inhibit the spontaneity of painting. Though you can always change your mind and add details by lifting out and repainting, it's better to establish them early and get them out of your way.

If you feel you need to add a figure to give focus to your painting, determine exactly where that figure will go. Draw the figure on a piece of tracing paper and move it around over the painting until you are sure where it belongs. Then rub a soft pencil lead on the back of the tracing paper, place the paper over the spot you've chosen on the drawing, and use a hard pencil or ballpoint pen to trace the figure

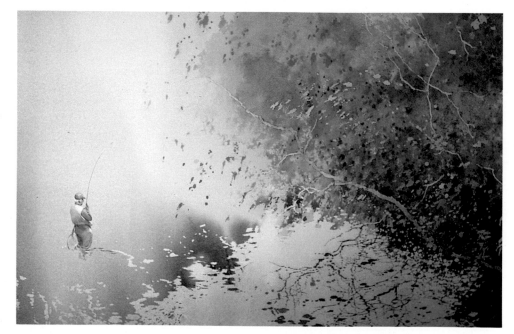

onto the painting. Scrub out the area with a brush and blot with tissue or use a small cotton swab to lift out the color. Then repaint.

One word of warning about lifting color out to paint in a detail: You're never really down to white paper again; there's always some paint left—a murky value. For a real white, you have to scratch out the paint with a razor blade or knife.

Foggy Fishing (21x12-3/4). *I often use little figures such as the one you see here to add interest, a focal point, or a human element to a painting.*

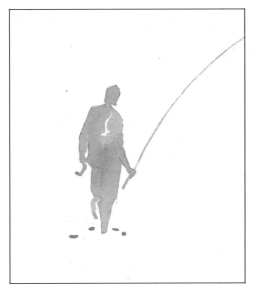

Step 1. *I carefully masked out my fisherman before I did any painting.*

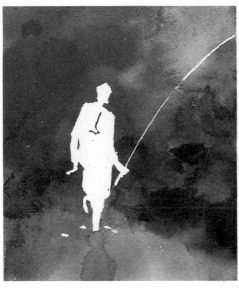

Step 2. *After I'd finished painting that area and let it dry completely, I lifted the masking and was ready to paint.*

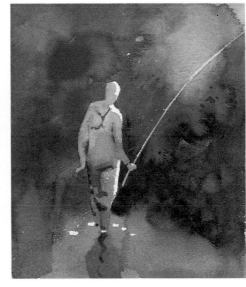

Step 3. *I worked around the highlight, which I visualized (pencil one in if you're not sure where it should go). I painted the fisherman with flat color and no detail, working from warm at the top by the light source to cool color at the bottom. When the figure had dried, I added some shadow—the crease in the boots and darks in the back of one arm. It looks three dimensional because of the highlight, which gives the figure some thickness.*

The Coho Run (21x14). *In the finished painting my little figure provides a focus for the viewer's eyes. The important thing to remember when you're adding figures to a landscape is to keep them simple.*

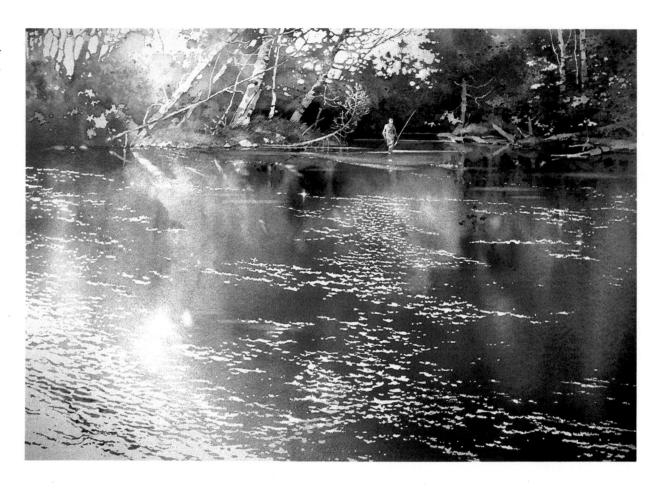

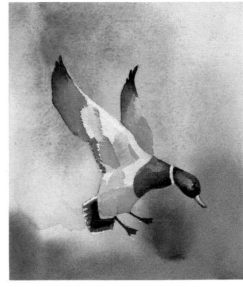

Step 1. *After you decide where you want to put the figure, trace it onto your finished painting.*

Step 2. *Gently lift out the background colors by agitating the area with a small, wet bristle brush and then blotting with a tissue. In this case I also used a wet cotton swab after blotting to get some lighter areas.*

Step 3. *I painted the darkest part of the duck first. The lighter part is the middle value I got from lifting the color off with a wet swab. I scraped out color with a knife to recreate the whites.*

TWO

INDIRECT PAINTING

*Masking, pouring,
texturing*

———

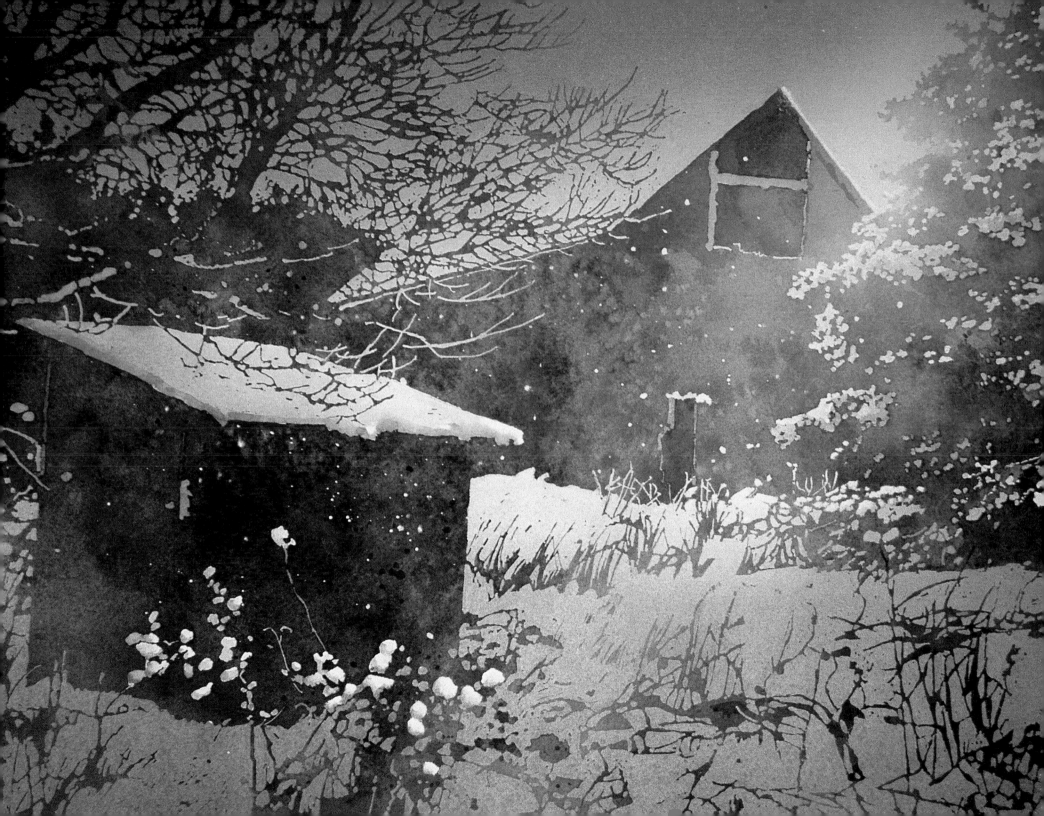

Color and Light in Indirect Painting

My paintings depict unusual lighting situations, which give them their special glow. When I pour transparent colors onto the paper, I'm really tinting the painting (glazing) to capture atmospheric light and color—and that gives my watercolors their unique look.

What's the difference between actual and atmospheric light? Actual light and color make up the way we normally see the world. Atmospheric light and color are the results of the light making contact with the atmosphere, producing effects such as sunrises, sunsets, fog, and so on.

Atmospheric light affects the color of everything. Fog creeping in over a landscape, for example, masks details and softens and grays all colors. In the early morning and late evening, when the sun dips down to the horizon, the warm light colors a gray building with shades of red, orange, or yellow.

Some of the most spectacular moments in nature can last only a

Michigan Dunes (14x10). *After the mixture of blues for the sky and the vegetation had dried completely, I poured Winsor yellow and Winsor red to produce a sunset atmosphere. Notice the glow the setting sun gives the reflective sand and how the cool colors predominate in the foreground. I poured a mixture of blues to create those shadows.*

fleeting moment—not long enough to get out a camera or sketch pad. In a flash the sun is a little higher or lower, and you have to wait twenty-four hours for another shot at what you wanted. Since I can't capture these effects any other way, I make them up out of my memories of these special events. I take the information recorded in my memory, draw on my photo file for subjects, compositions, and details, then manufacture the atmospheric effects to make the scene unusual.

I prefer to paint backlit scenes to make the most of atmospheric light. At early morning and late evening, everything is silhouetted. Under these conditions of atmospheric backlighting, foreground colors, which are farthest from the light source, are cool, and background colors are warm. (This is the reverse of what we normally see; usually the farther away things are, the cooler they appear.) As a result, the actual color of the object is replaced by the colors of the atmosphere plus the cool of the sky. So a red barn doesn't look red under backlight— it looks cool and purplish.

Dawn of Another Day (21x14). *Backlighting and atmospheric color can add drama to the simplest subjects. I'd passed these old farm buildings many times, but they never "spoke" to me until I happened to see them on the early morning school bus run. They came to life, warmed by the light and colors of the sunrise. The best subject matter for backlighting is something with an interesting and identifiable silhouette. Notice how the colors of the buildings and the grassy slope change as they take on atmospheric color near the light source.*

What is Indirect Painting?

Indirect painting is a combination of careful, precise drawing and the uncontrolled application of paint by spattering, throwing, and pouring. This method appeals to both my emotions and my intellect, to my need for fantasy *and* realism in my work. The drawing and masked portions control the realism, but pouring transparent colors onto the paper really makes things look unusual by capturing atmospheric light and color.

Pouring is actually a form of glazing used to modify the existing coloration of the painting. It creates an atmosphere for and unifies the whole painting. You begin with the color slightly darker than you want in the final painting because your pigment will get lighter as it spreads over the wet paper. (And, of course, watercolors always look much lighter when they're dry.) Sometimes I get a shock when I see the final result, but those disappointments are just part

A Quiet Hole (14x21). I masked out the foreground leaves, the tree, the rocks, and the highlights on the water. Using rich colors I painted in the foliage, sprinkling salt to create diffused leaves in the background. I painted wet-in-wet the deep shadows in the water. Then I removed the masking, painted the leaves in the foreground, and poured in the foreground. I lifted the highlights with a bristle brush.

of working with watercolor. Use of this technique does not guarantee a successful painting; it is a tool for adding special effects of color and light to your work.

Because my particular technique requires starting with the darker and working toward lighter values, I mask the lights and highlight areas that would be hard to paint around to protect them. The masking agent allows me to paint faster, and be freer—more wild and spontaneous—than would otherwise be possible.

I handle the technique in three different ways: 1) Masking the lights, painting in the medium values, and working toward the darks; 2) Masking the lights, painting in the darks, and pouring in the medium values; or 3) Masking all except the dark areas, removing the initial masking, and then applying a second masking to the light areas only.

Stormy Seas (21x14). *Here, the subject matter dictated my method. I masked the lights, painted in the darks, and poured in the medium values. I began with the dark shadow area, then poured the water over it, using every blue in my palette except Payne's gray (which has too much black in it and would cause mud). The pouring blurred the underlying paint layer—ultramarine blue and a bit of Winsor red— picking it up and making it run. Because water is transparent, I couldn't use any opaque colors. Pouring this way enhanced that transparency; the water looks like it's lying on top of the shadows, especially where I created those blurry edges. Then I scraped in some whites with a razor blade to define the sparkle on the water.*

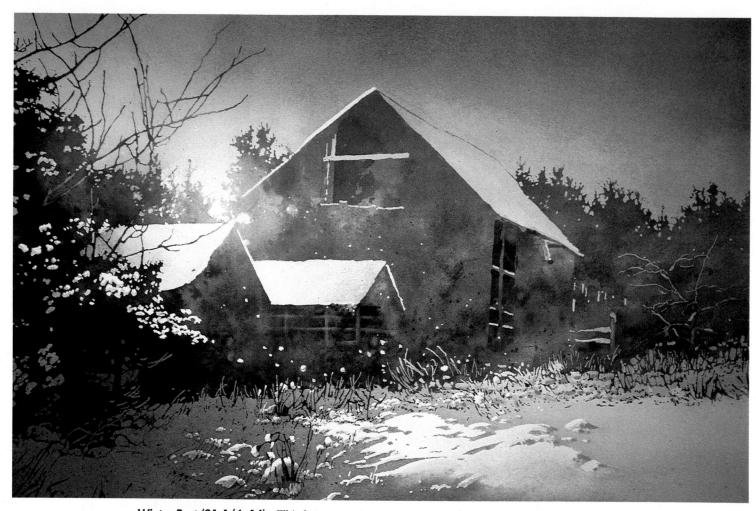

Winter Past (21-1/4x14). *This barn grouping is a remnant of the twenties. There isn't much left now, but at sunrise the buildings come alive. I masked out the sky and snow areas, then brushed and threw paint into the rest, starting with the warm and working toward the cool. I removed the original masking and remasked just the highlights on the snow. I poured in the sky and snow, then removed the second masking. I finished by pouring in more blue on the snow to soften the highlight away from the light source and painted in the shadows on the barn.*

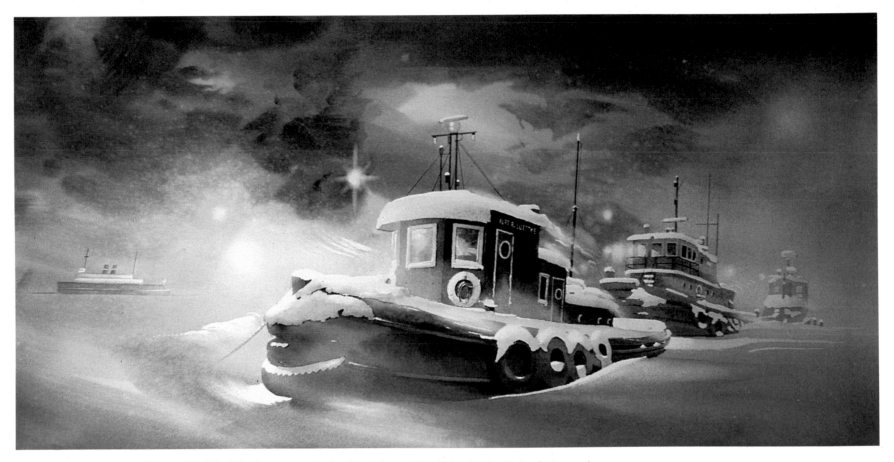

The Family (29x14). *In summer the harbor is busy with all kinds of activity, but now the warm weather and charter boats are gone. Only a fleet of tugs and an abandoned car ferry remain. The evening winter winds are howling and snow is blowing. To capture that feeling I masked out the highlights and painted the sky on wet paper. Then I poured on the drifting snow. I lifted the masking and painted in the details on the tugs. Pouring in the atmospheric colors created the bleak feeling without leaving the scene dull or lifeless.*

Masking to Control the Drawing

After I carefully pencil in the composition, I begin the most important step—the masking process. This is when I block out the actual subject that will make the painting look realistic. The pouring and texturing stages that follow the masking determine the colors and surface richness, but I design the painting during the masking stage.

Various masking solutions are available. I prefer Maskoid because of its light gray color, which lets me see the patterns develop as I work.

I dilute the Maskoid to a watery consistency for easy application and removal. Since the consistency of Maskoid varies, I can't tell you exactly how much water to add. If you have to push it to put it on, it's too thick. It must be thin enough to flow through a pen. When opening a new bottle, I pour about a third of its contents into each of two empty Maskoid bottles. Then I top off the three bottles with water and stir.

Maskoid is hard on brushes, particularly if allowed to dry in them.

I use a rope brush, a sharp twig, and a brush handle to apply masking.

I apply Maskoid with a twig to get fairly thin lines. Where detail is less important, I use a piece of rope.

Cigarette lighter fluid or a similar solvent can be applied before the Maskoid hardens, but using it is still a nuisance. To avoid ruining my brushes, I make my own applicator tools and find they work just as well—sometimes even better—and require no cleaning up.

I've collected an assortment of different kinds of stiff rope and twine to use in making these tools. For example, I cut off a piece of rope about six inches long and tape it to the handle of an old brush or a one-quarter-inch dowel rod. When I'm done I simply cut off the used piece of rope with my scissors, and slip up a fresh piece. For smaller areas I use a twig sharpened to a point. To remove the masking agent, I rub it with a rubber-cement pickup.

Always let the Maskoid dry naturally. If you try to speed up the process with a blow dryer, you may cause the Maskoid to adhere permanently to the paper. Also, do not hasten drying by placing in the hot sun; the Maskoid can turn gummy and be difficult to remove.

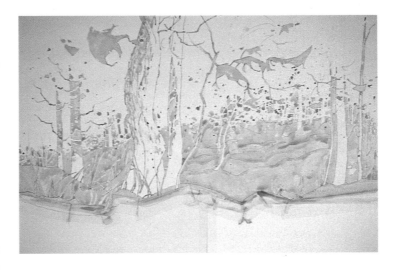

I masked only the light areas before beginning the painting. This is negative painting as it is all in reverse and makes a beautiful abstract pattern.

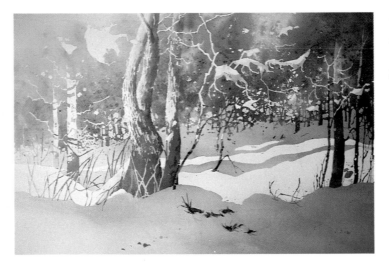

The Morning After (21x14). *Now compare the finished painting with the masked area.*

Color Mixing

Since natural light is cool, the only colors I pour from saucers are Winsor yellow and Winsor red (the cool primaries). They're used by themselves strictly for atmospheric purposes: to create a mood, feeling, or presence under unusual lighting conditions.

I also put a small dab of Winsor red on the edge of the rim on both sides of my palette. (Keep the red away from other colors; it's strong and will pollute them.) Winsor red mixed with cobalt blue makes a lovely violet and mixed with ultramarine blue makes a very nice purple.

Blues can indicate shadows in the snow, sky reflected on water, shadows on beach sand or dunes, and so on. They're poured from the palette because each painting requires a different combination of mixtures from the various blues: cobalt blue, Antwerp blue, French ultramarine blue, cerulean blue, and Payne's gray. I keep the main blues for mixing—cobalt blue, French ultramarine blue, and cerulean blue—at the bottom of my palette where there is the most mixing space. I can bring in the other blues as needed by adding water to them and tilting down the palette tray. Generally, I keep a small block under the top of the palette so that excess water or color mixtures will run to the bottom. This keeps the colors at the top from getting too mushy.

Cobalt blue is a weak color, so keep a good supply on your palette. Cerulean blue is a very opaque color, useful for brightening cool shadows and for softening the harshness of ultramarine blue. Payne's gray and French ultramarine blue are darkening colors when mixed with any of the others.

Except for the blues, all color mixing is done on the paper. This helps to retain freshness of color and depth, since each pouring goes on slightly differently.

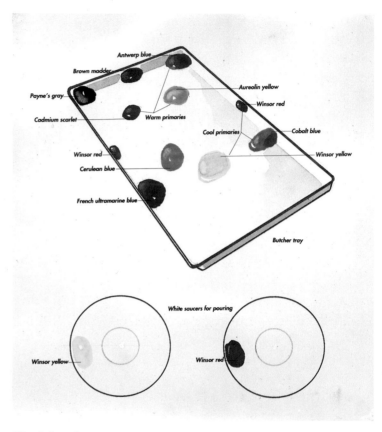

Here's how I arrange my palette. As you can see, I put Winsor yellow and Winsor red on saucers for pouring and on the palette for mixing. I leave a large space at the bottom for mixing blues for pouring.

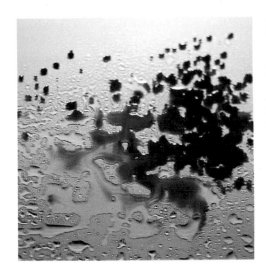

Let's look at how colors mix on the paper. I mist the paper first, then spatter color onto it. The paint interacts with the water, lightening and thinning in some areas and remaining untouched in other areas.

When a second color is added, the two colors blend in unpredictable ways.

Now I add a third color. I use the three primaries because their blending most resembles the effects of real light.

The colors blend without getting muddy because I don't mix them with a brush; I let them merge naturally.

I also let the colors blend at random; the final effect depends on how I tilt the board. The key to controlling the flow is practice, though in many ways, the painting paints itself.

32

Misting the paint also helps improve its flowing action.

Butterfly on the Betsie (14x21). *Here you can see how it's all come together. Pouring colors creates an interesting, subtle blending of hues.*

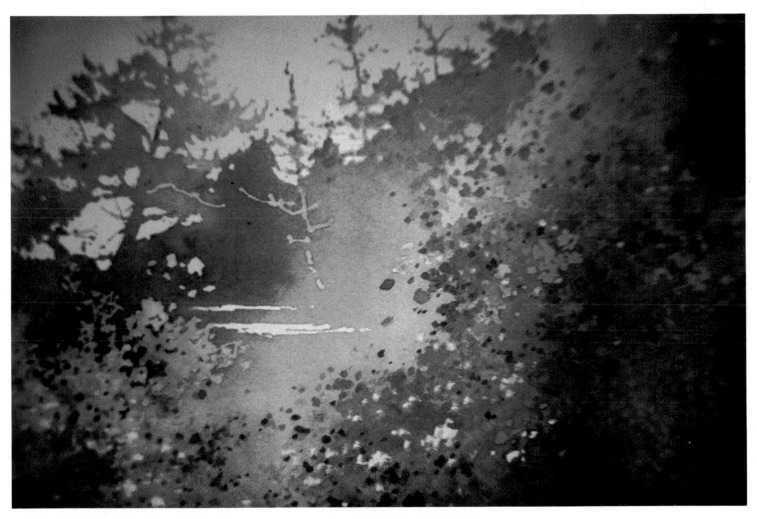

This detail from Butterfly on the Betsie *clearly shows the blending of colors and how they come to represent a fairly realistic landscape shape.*

The Pouring Process

I begin by misting the paper with the spray bottle and then pour off the excess water. I dilute the Winsor red and Winsor yellow—each in its individual white saucer—and pour them, one at a time, on the wet paper. I control the direction and intensity of the color with the spray bottle and by tilting the board.

I usually start with Winsor yellow as the first pouring color. Winsor yellow is the lightest color I use and it influences the next layer better than a darker color would. The first color applied in glazing predominates because it soaks into the bare paper. The subsequent colors only alter the hue. I follow the yellow with Winsor red, then the blue.

Pouring is not an exact science, so the color frequently wanders into an unexpected area and produces a "happening" that adds to the effect. The masking agent acts like a dam to hold back the paint, so you have to tilt the board in addition to misting to force the poured paint over the dam and make it run off the side.

If the first pourings are too weak, you can repeat the process. In fact, several pourings of different blues will give more depth than a single pouring of a mixture. Just don't forget that the fewer the layers the better your finished painting will look!

I let the excess color run off the edge of the paper. Otherwise, a watermark or ring may appear at the edge of the puddle. Each layer *must* dry before the next one can be poured. A blow dryer can hasten this process.

The various nuances of color that result from using the different primaries give life to the picture. Several pourings from each side of the painting are required to control the colors properly, especially on a full sheet. You have to develop a sense for when the proper intensity has been reached.

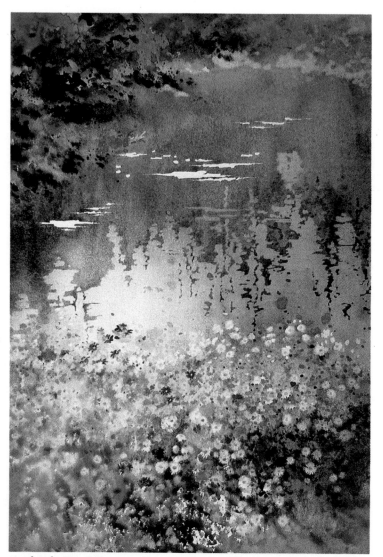

Pool Side (14x19). *Although I pour and roll colors across the surface of my paper, the results aren't haphazard. By repeating layers of glazing, I can create the delicate color gradations you see here.*

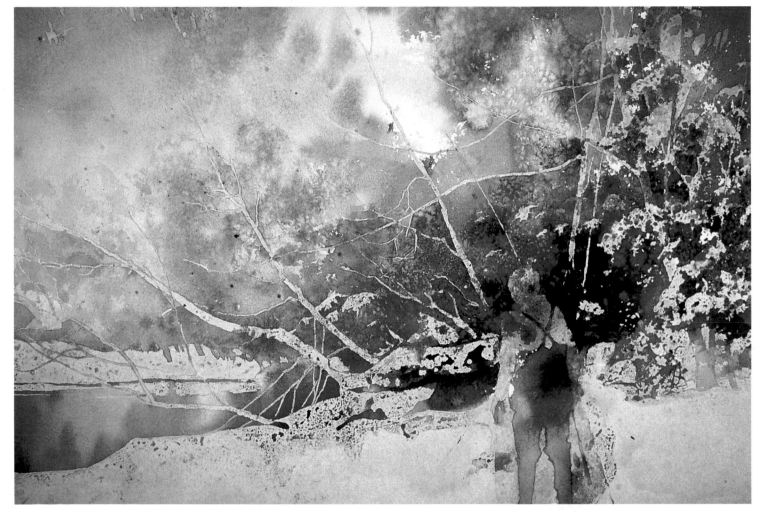

After I applied the Maskoid, I poured on the blues. Although I generally start with the yellow, this time I needed effects I could get only by working in this order.

Next I poured on the yellow. I don't mix the washes as I apply them. Secondary colors, like the green foliage here, result from the layering of each wash over the previous one. Remember to let each layer dry completely before you pour the next primary color.

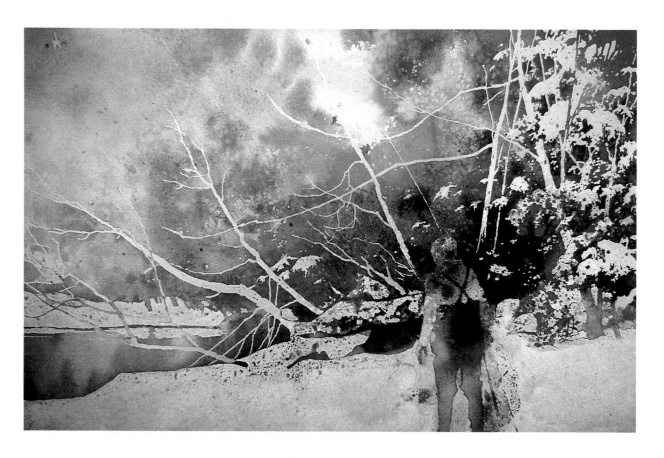

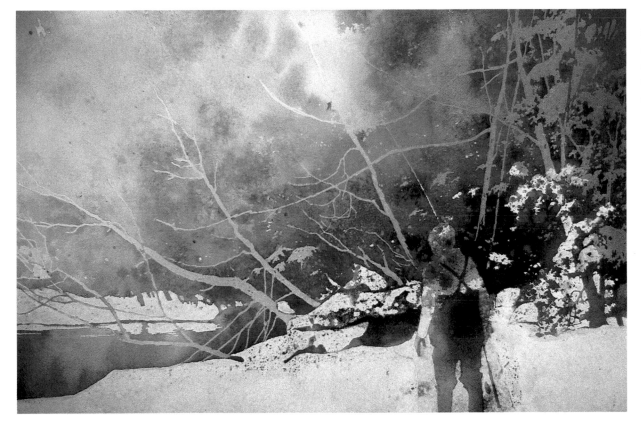

Then I poured on the red. I use a spray bottle to spread the wash around without using my brush. Misting the areas where I want less color, I tilt the paper so the color crawls and rolls over the surface. When I'm done, I pour the excess color from the paper.

I wasn't quite satisfied with the result, so I added some more reds before removing the Maskoid.

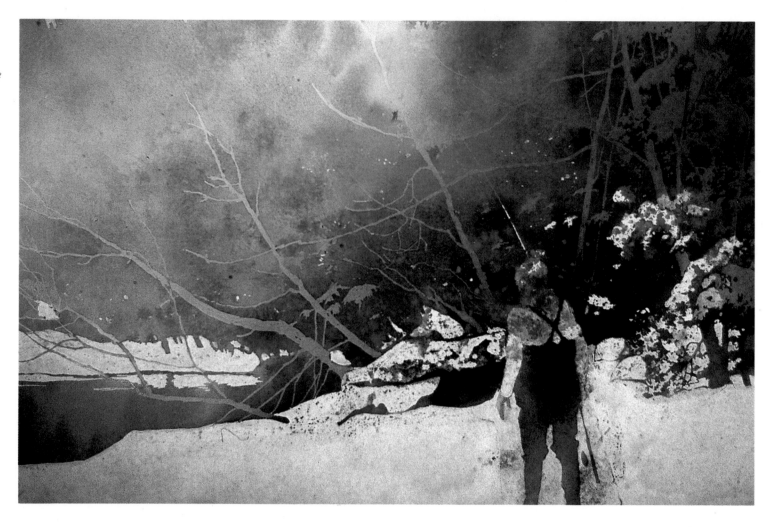

40

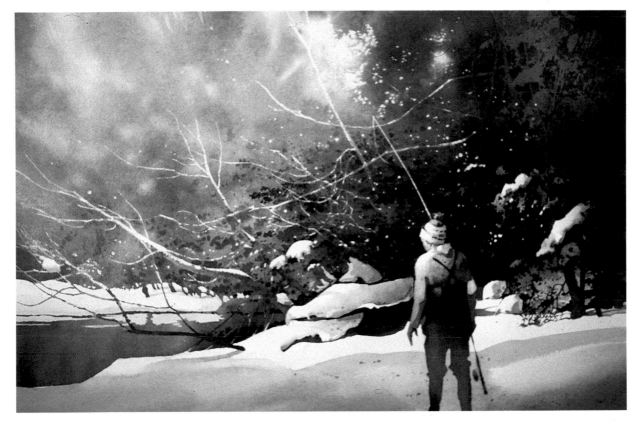

Winter Wader (21x14). *I painted the final details directly with a brush. I started with the light source on one side of the painting, but as it was developing, I changed the light direction. This kind of change happens from time to time, because paintings take on a life of their own as you work on them.*

Texturing for Effect

My paintings are usually a mixture of textured areas and smooth, gradated areas. Here are several techniques I use for texturing.

Spattering: Paint spattered onto a misted paper creates some very interesting leafy textures if you have varied the amount of spray water. Paint can also be spattered onto dry paper for harder effects.

Misting and Spraying: Misting the paper with water before paint is applied produces unpredictable textures. Tilting the board will further accelerate the flow of pigment in the water, and additional misting will break down the texture into smaller fragments. By alternating between misting and spattering pigment, you can build up the texture because some areas will dry faster than others. Control the amount of water on the paper by occasional blotting with a tissue.

A light spraying of water on a heavily painted, still wet area creates small back-run effects. Salt sprinkled on a fresh application of paint results in a more uniformly

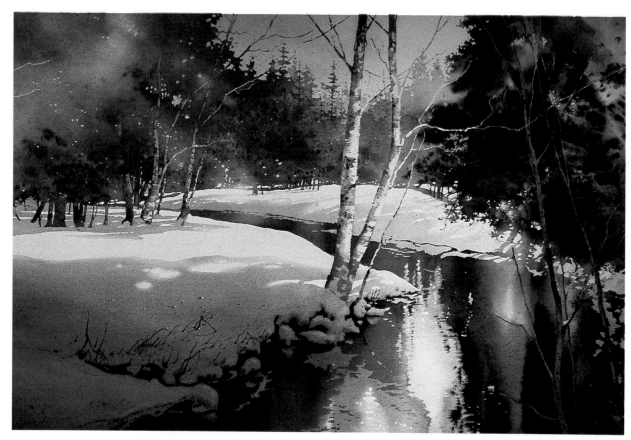

Sifting Snows (29x17). *This shows how gradated and textured areas are blended in my paintings.*

42

sized back-run effect and can produce other textures as the paint dries.

Wiping Outward: Wiping the wet pigment outward in a fan-shaped pattern produces the effect of a water explosion similar to surging waves on a rocky coast. It is all a matter of timing the wetness of the paper and the interaction of water and pigment in order to suggest the beautiful effects of nature.

Scraping Out: To indicate bark on a tree or the sharp lighted angles on rocks, you can scrape the wet paint with a knife. A pointed implement such as a brush handle or the handle of a pair of fingernail clippers can be scraped on freshly applied paint to indicate grass or twigs.

Knifing out pigment while it is still wet produces two different effects. First, the scraping will dent the paper if the surface is quite wet; the surrounding liquid pigment will run back into the crevice and produce a darker mark when dry. Second, if the pigmented surface is only moderately wet, the scraping will push off the surface color, leaving a

Spatter works well for foliage.

43

lighter stain on the paper. The wetness of the paint on the paper determines whether the results are positive or negative in shape and form.

Paint can also be scraped from a dried area by rewetting it first to soften the paint. Try these different effects on scrap paper to acquaint yourself with the results.

Spraying into wet paint also creates interesting textures by making small back-runs of irregular sizes.

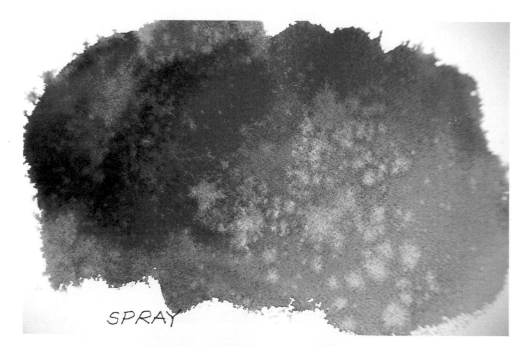

SPRAY

Salt applied to wet paint leaves crystalline, irregular edges and shapes that are quite uniform in size. When you work with salt, keep the paint quite wet. Because each color has a different chemical composition, each mixture of colors reacts to the salt differently. You'll have to experiment to find out which ones work well together.

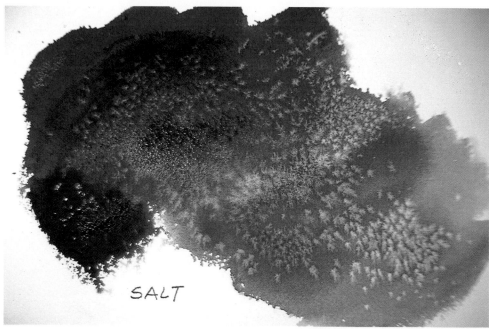

SALT

I created the trees, rock, and foreground grasses in this sketch by scraping out with a knife.

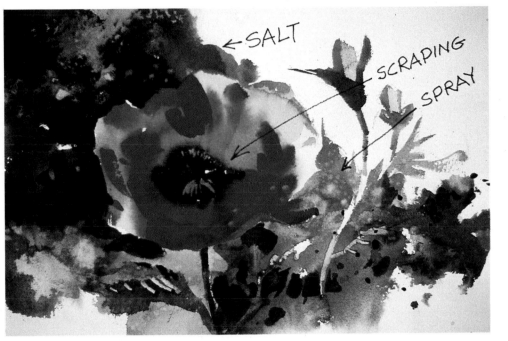

Here's a quick sketch in which I've combined a variety of techniques: using salt, scraping out, and spraying.

On the Edge II (19x14). *Unlike most of my paintings, I did no masking or pouring. Instead I used a number of texturing methods—spraying and misting, scraping out, and wiping outward. You can clearly see how, by wiping the wet pigment outward, I produced the effect of surging waves on a rocky coast.*

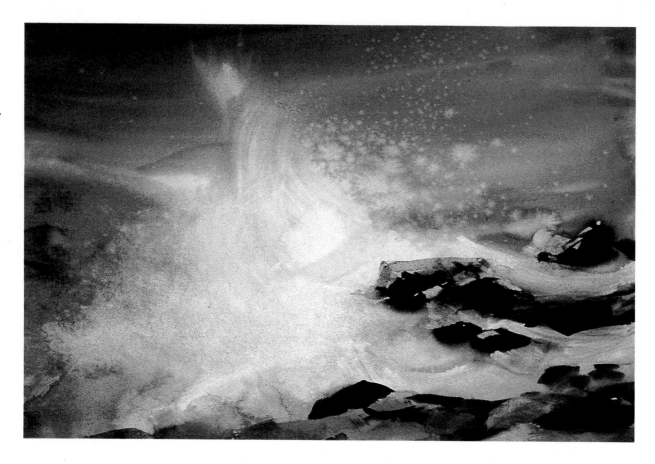

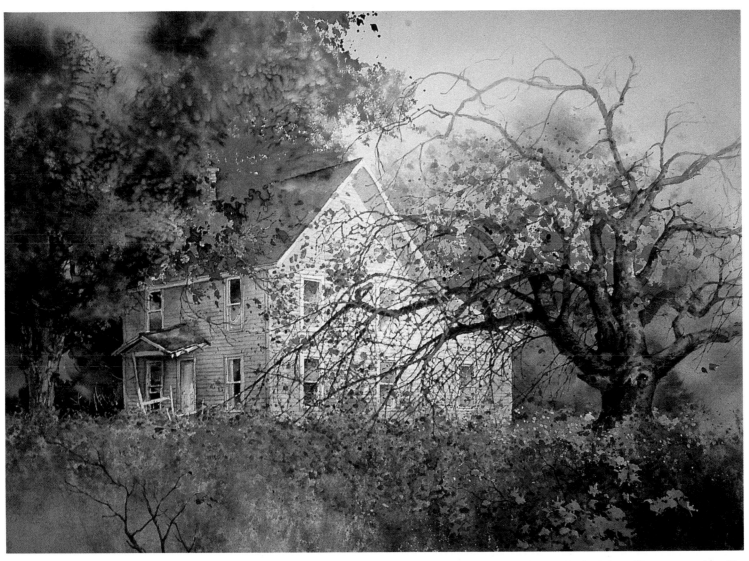

The Old Apple Tree (29x21). *I walked through tangled roots, poison ivy, and shoulder-high brambles to get to this old farm house. The barn had decayed long ago, and only the concrete foundation was left along with this huge apple tree that I imagined had once been planted with love. I've used two different effects to texture foliage here. The apple tree in the foreground was done by spattering. The maple in the background was done using salt.*

A Look at the Process

To wrap up our overview of indirect painting, we'll look at the major stages in the process so you can see how masking and pouring work together to make a painting. Then I'll take you through a more detailed demonstration in the next chapter.

I begin my paintings by wetting a sheet of 140-pound Arches paper on both sides with a sponge and letting it soak for about five minutes before I staple it down to a piece of 3/8-inch plywood. (Arches is the only paper I've found that's strong enough to withstand the punishment of masking and pouring.) When it's dry, I tape the edges to prevent paint from running under the paper during the pouring process. The tape acts as a dam to control the poured paint. The taped edge also serves as a sort of mat, letting me check my work as the painting progresses. Then I mask out the light areas and prepare to paint and pour.

Frozen Shoreline (21x14). *I masked only the snow on the heavily laden boughs. Then I painted in the background, starting with the sky and snow area. Next I worked the evergreen tree itself, gradually extending the boughs as my intuition led me. When the paint was dry I removed the masking. I refined it a bit, painting in shadows on the snow clumps and adding detail to the tree. Now I had medium and dark values, but I felt the lower left corner needed more warmth to balance out the distant woods. I poured on alternate layers of yellow and red, which produced a nice reflected light. Finally, I lightened the background at the edge of the tree by scrubbing it with a moist toothbrush, because I wanted the painting to look as if there was a distinctive light source. The painting didn't seem to have a reason for being—a center of interest—so I added the chickadee to finish it off.*

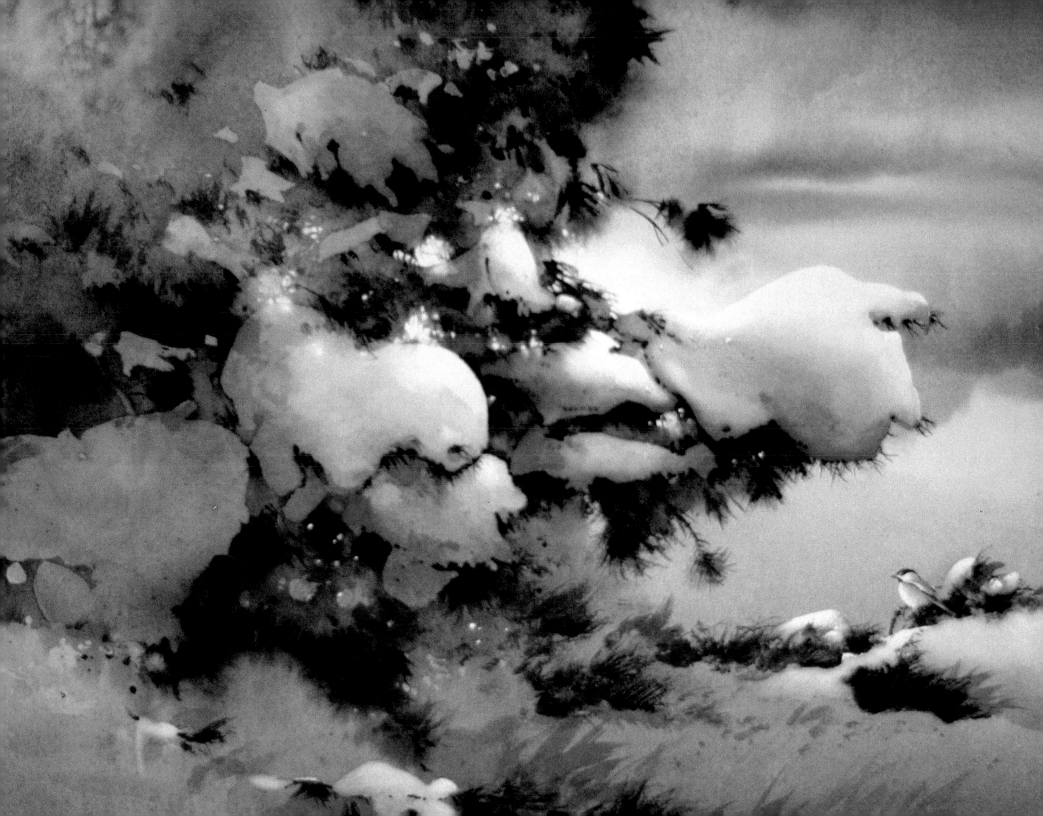

For this painting I masked out both light and middle values. I used my stick and the rope brush to apply the Maskoid, then spattered some on as well.

With the lighter areas protected, I could work freely on the darks. I threw on the paint liberally and also used some salt to create leaves.

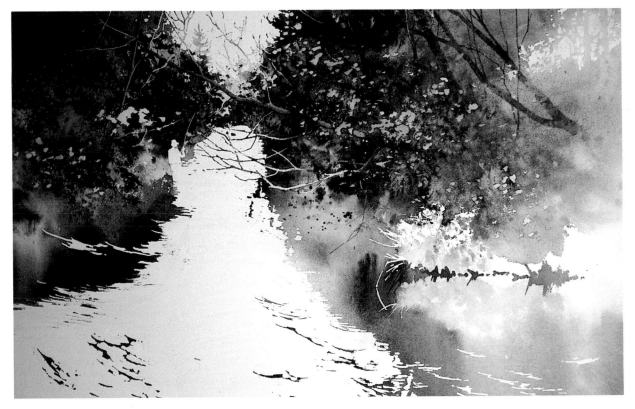

After removing the masking with a rubber-cement pickup, I decided that I wanted some brightly colored leaves near the center of the right-hand foliage area. I painted those directly with a small brush.

This time I masked out only the highlight areas, including the fisherman and the brightest-colored leaves.

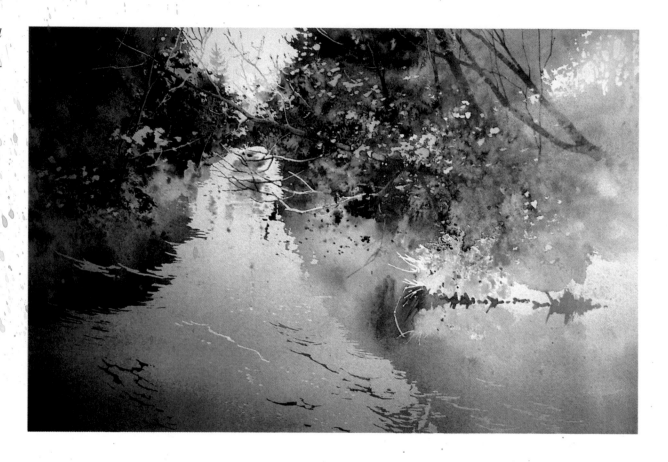

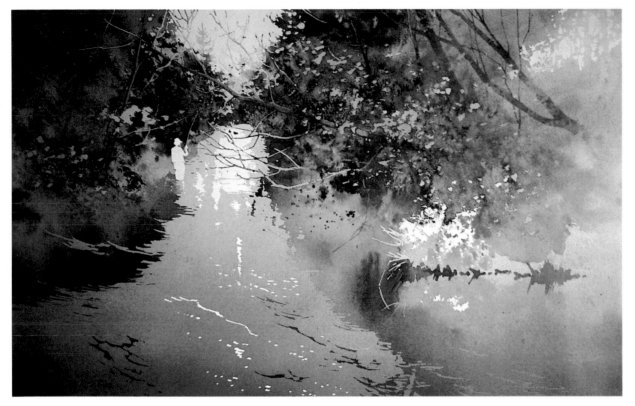

When the masking had dried, I wet the paper with a spray bottle and poured the colors—yellow first, then red and blue—onto the surface. I added some yellow glazes to the foliage areas to fill the negative spaces between branches and repeated blue glazes to the water to achieve a rich coolness. Tilting the board to move the paint where I wanted it, I poured off the excess and dried the surface with a hair dryer.

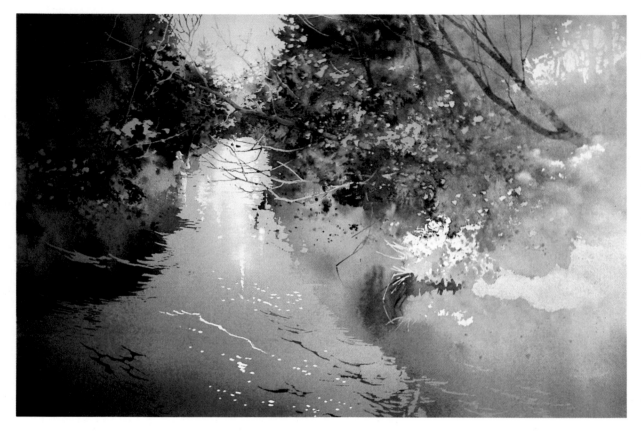

When the paper was dry and I removed the masking, I could clearly see all three values and evaluate the picture as a whole.

Anticipation (14x21). I painted the final details, such as the fisherman, directly with a brush. I also used a damp bristle brush to soften some of the hard edges left by the Maskoid, particularly in the foreground water area on the right.

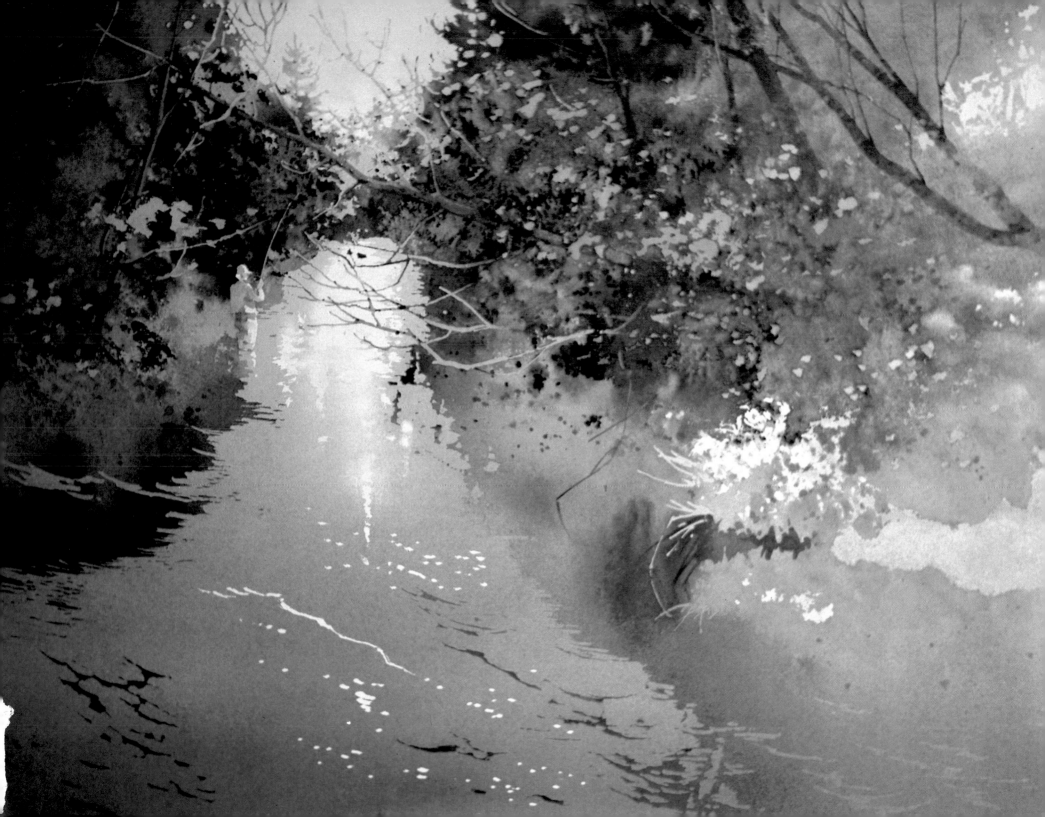

THREE

LET'S MAKE A PAINTING

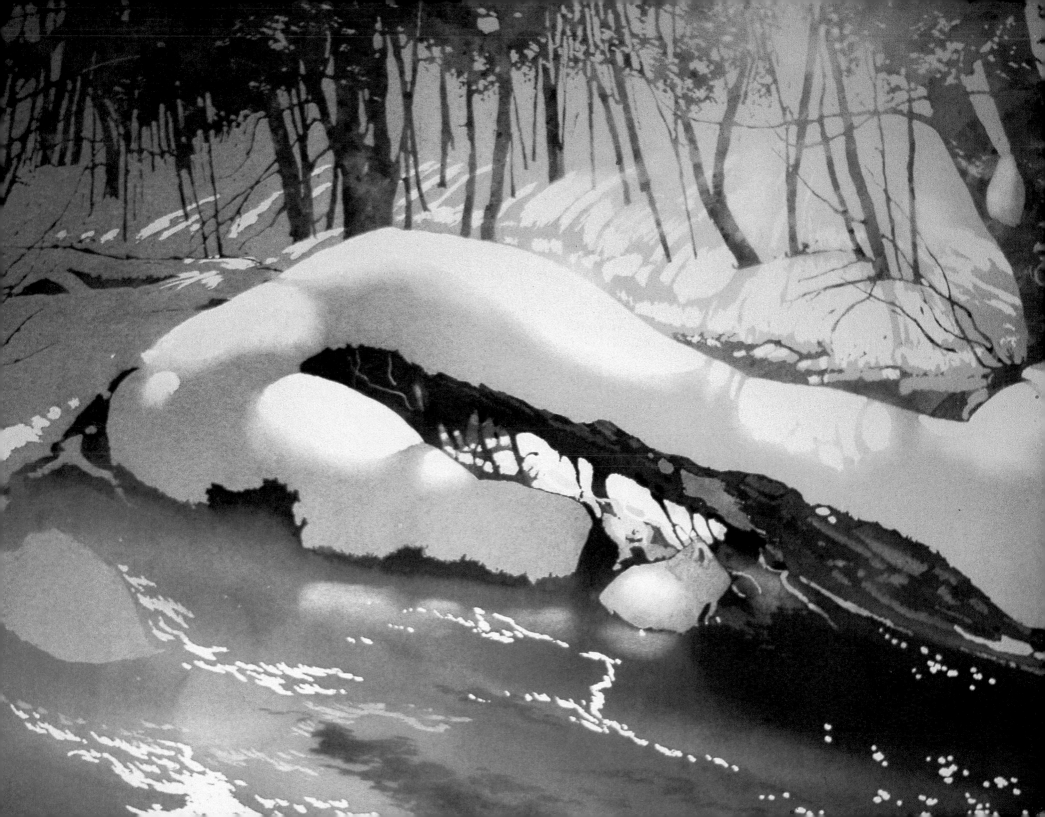

Before We Begin

In the last chapter we looked at the basic techniques of indirect painting: masking, texturing, and pouring. Now we'll follow one painting from start to finish. You'll observe the step-by-step process and notice that I may do a certain step several times; for example, I may work on the texture in an area more than once because I need several colors there or want to achieve different effects.

The following outline mentions masking the painting once and removing that masking only once. Depending on the effects I want, however, I may remove and reapply masking several times at different points in the painting process. Rather than adhering rigidly to one certain method, I let each painting evolve in its own way. Let's quickly review the process:

1. I sketch the details on the paper and apply masking.
2. When that's dried, I tackle the textured areas.
3. I tilt the board, mist the paper, and mop up excess water.
4. I prepare the saucers of Winsor yellow and Winsor red.
5. I pour on layers of color, generally beginning with the yellow.
6. I let each glaze dry completely before applying another.
7. I pour on the red next, allowing each layer to dry as before.
8. I mix the blues on the palette and then pour the same way.
9. I remove the masking.
10. I evaluate the painting and make any necessary changes in color.
11. I add the finishing touches—details and refinements.

I've set the composition and the value plan with this thumbnail sketch.

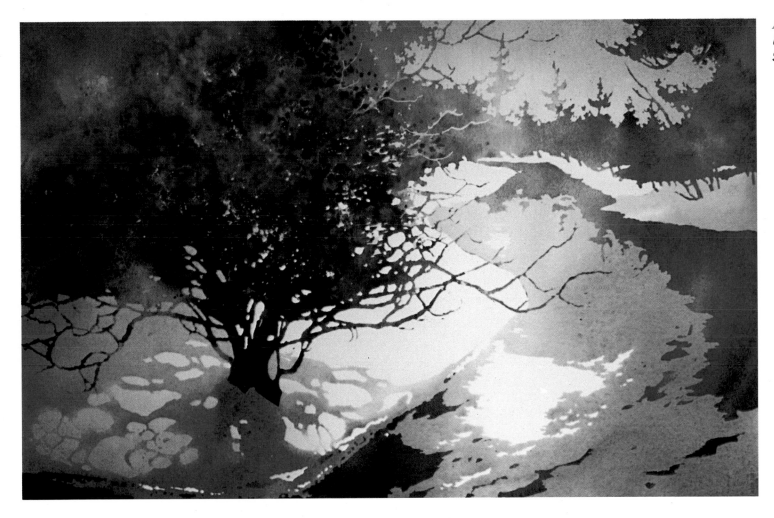

And this is where I'll be going: **Winter Shadows II.**

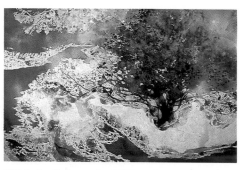

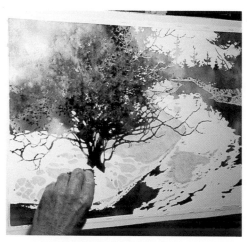

After I sketch in the details, I apply the masking with my homemade tools—a twig for fine lines, a piece of rope for larger areas.

With the light and middle values masked out I can work on the darks freely—brushing, spattering, and dripping color. I also use salt in certain areas.

Here I'm removing the Maskoid with a rubber-cement pickup.

This is how the painting looks when the Maskoid is removed.

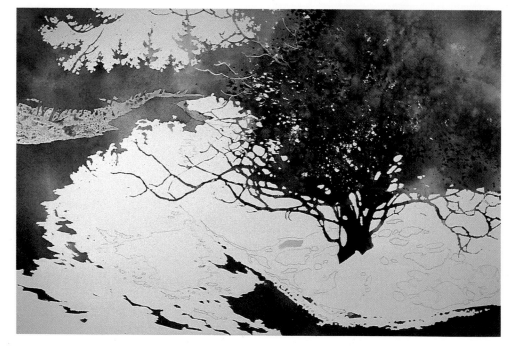

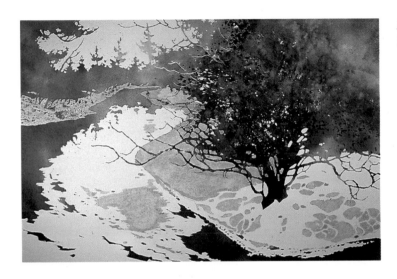

I remask just the highlights this time.

I prepare the paper for pouring by rewetting it with a sprayer.

I have to wipe off the excess water from the edges of the paper to prevent paint from being attracted there.

I spray water into the saucer to thin the paint and make pouring easier.

I begin the pouring process by tilting the board slightly and carefully. Then I pour the color on a preselected area of the painting (generally Winsor yellow as I'm doing here).

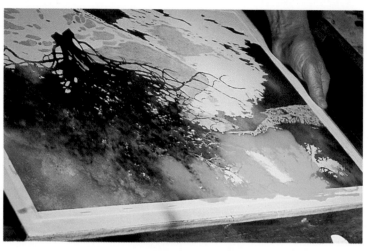

I tilt the board to direct the color where I want it to go. Then I pour the excess off the paper and back into the saucer.

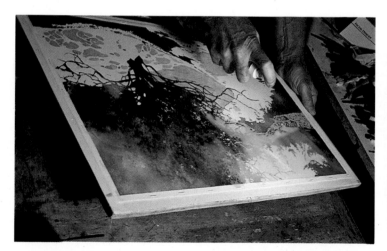

I spray the wash while still wet to redirect its flow and lighten the value.

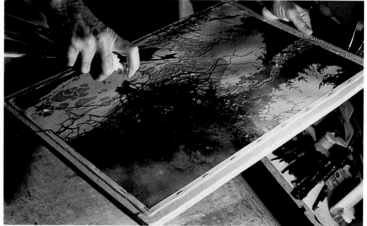

It still needs some work, so I push the paint again by spraying the paper and tilting the board.

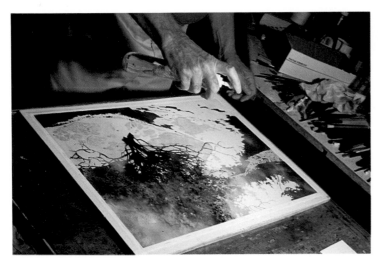

I keep spraying to lighten the work until I get just the right value.

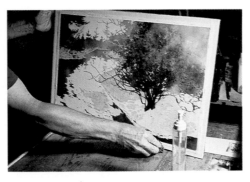

I have to wipe off the excess water after each pouring so the color won't run off the edges.

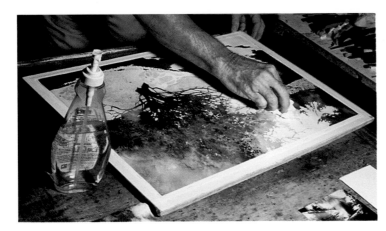

Next I blot the paint in places where I want the color to be even lighter.

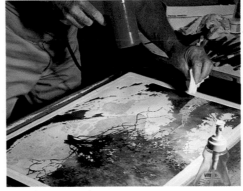

I usually blow the paint dry with a hair dryer and blot off some areas simultaneously to save time. You can test the paper with the back of your hand to make sure it's dry before pouring again. If the paper is cool, the moisture is still evaporating; keep drying it till the paper is warm to the touch.

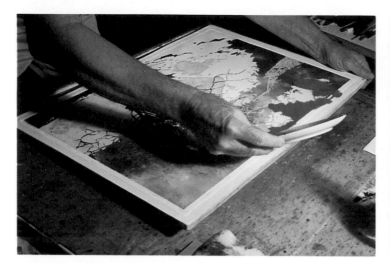

Now I pour the Winsor red from its saucer.

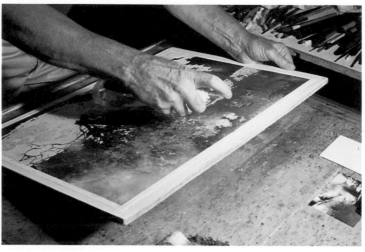

Again, I direct the paint by tilting the board and spraying, just as I did with the yellow.

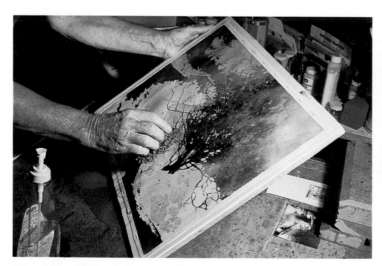

Here I blot off the excess paint with a sponge.

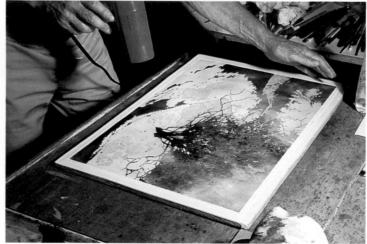

Then I fix the wash by blowing it dry.

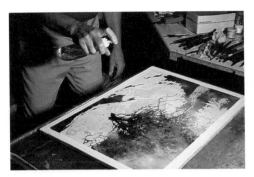

I mist the paper to prepare it for the next pouring and wipe off the edges again.

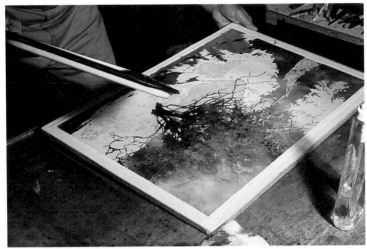

I mix the blue on the palette, because I usually need several blues to get the color I want, and pour straight from the palette onto the paper.

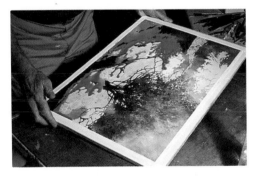

I tilt the board to direct the paint again. . .

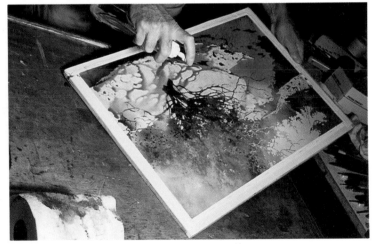

. . .and spray to direct the paint flow.

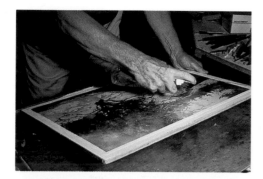

I also spray to soften and lighten specific areas.

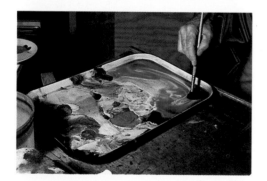

After I've cleaned the edges, blotted off the excess paint, and dried the layer, I mix up another layer of blue. . .

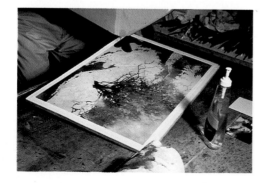

. . .and pour it on to darken one corner.

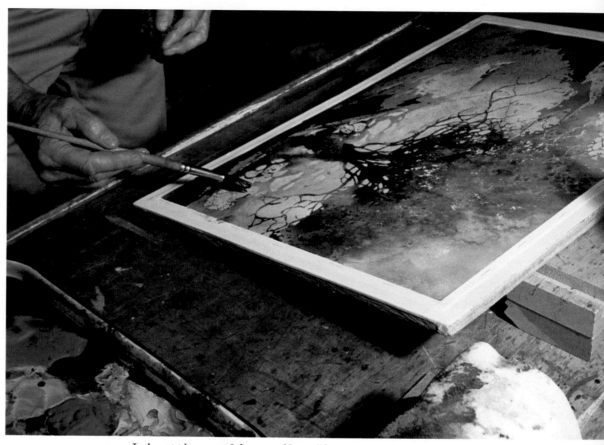

I also apply some of the same blue with a brush (direct painting).

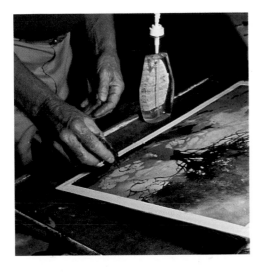

After blotting and blowing the paint dry, I texture it with a sponge.

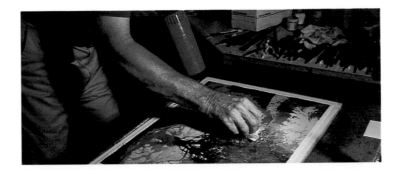

Then I lighten some areas by blotting and blowing them dry.

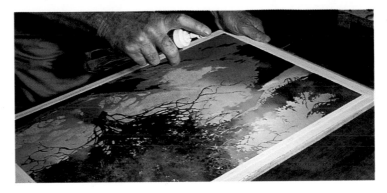

Here again I'm pouring selectively and spraying to direct the flow of the wash.

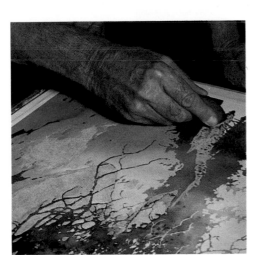

Finally, I remove the Maskoid from some areas while leaving it on the highlight areas.

This is how I create a glow.

Then I remove still more masking to expose white paper for texturing.

Then, I switch to another blue, pouring it into newly exposed areas.

First, I remove more Maskoid, leaving the highlight areas covered.

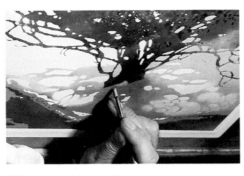

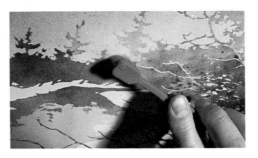

With a small brush I brush out light areas.

I lighten areas with a toothbrush. This is hard on the paper—a good reason to use Arches.

After wiping off the edges, I lift selected Maskoid layers, then correct the darks by painting into them.

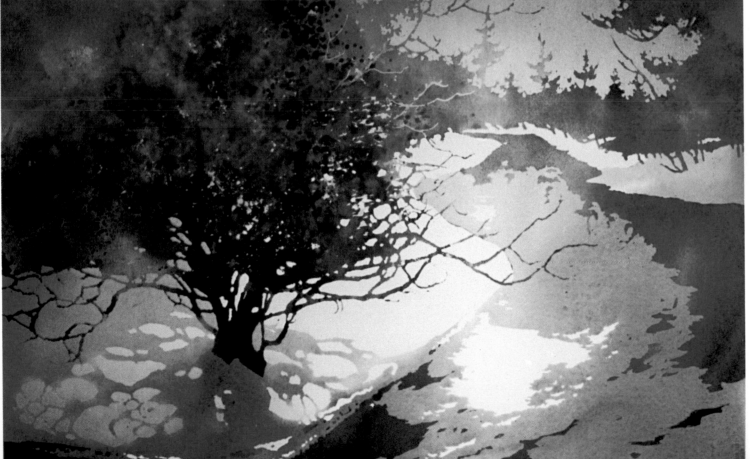

Winter Shadows II (21x14). *I remove the rest of the Maskoid with a rubber-cement pickup, and I'm finished. Look closely to see how I've indicated the light source and how the light filters through the trees.*

69

SEARCH FOR A PAINTING

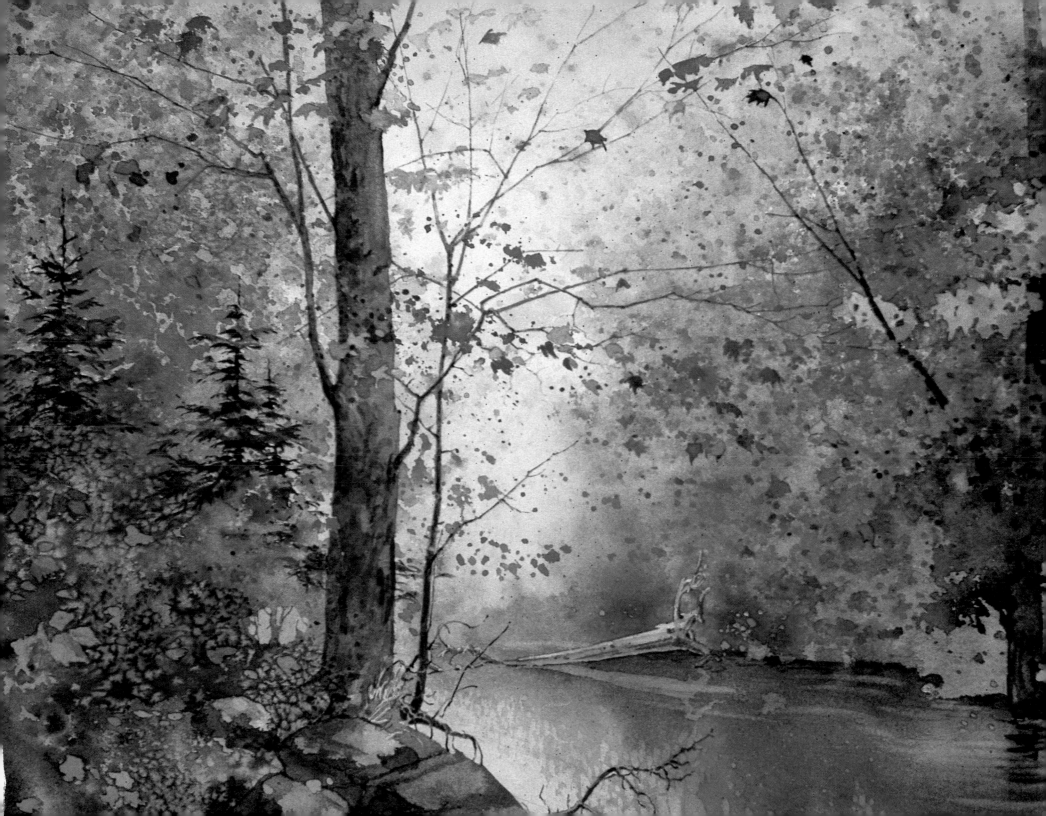

The Bar Theory

Joseph Haydn's oratorio, *The Creation*, captures the atmosphere of the first moments of the earth's inception as few other works have. The oratorio follows the opening lines of Genesis. "In the beginning God created the heaven and the earth. And the earth was without form, and void; and darkness was upon the face of the deep. And the spirit of God moved upon the face of the waters. And God said, 'Let there be light': and there was light." The first climax in the music comes with the words "*and there was light.*" This seems especially appropriate to me because there would be no life without light.

These musical and biblical themes have inspired the simplistic generality that helps me understand the three-value approach to landscape painting. I would like to share this approach, which I call the *bar theory*, to help you with your own painting.

In the bar theory, the vertical dimension of your paper is divided into three unequal segments or bars (an equal division would be visually less interesting). The upper portion, the sky, is a light value bar because it is the source of light. The bottom bar, or land area, is nonreflective and of medium value, as the light hits it directly. Vertical objects, such as vegetation, buildings, and steep cliffs, are dark in value since they are the least affected by the light. This dark value becomes the middle bar of your composition.

For a winter scene, because snow is white and reflective and the sky overcast, the values of the three bars are reversed. Instead of sky/light, vegetation/dark, land/medium, the bars are land/light, vegetation/dark, and sky/medium.

If you eliminate either the sky or land mass, a landscape painting may also have just two bars. The bar theory is especially helpful in intuitive painting, where the correct value must be obtained on the first pass. Overpainting can cause you to lose freshness, particularly if earth colors are used.

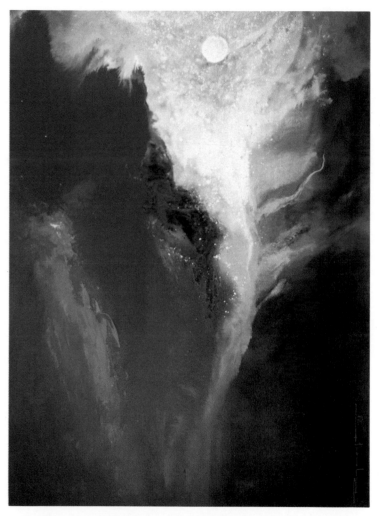

In the Beginning (©*1979, acrylic, 21x29*). *Pouring, to me, reflects the formlessness of the earth. But the landscape evolves out of this through the application of the abstract principles of the bar theory and by masking.*

Winter Winds (18x6-1/4). I used the bar theory to paint this. Note the interesting action line formed by the land shape against the sky. I worked quickly, just reacting to what was happening on the paper. Once you've set your composition using the bar theory, let your eye dictate where different elements should be placed. This is where intuition comes into play.

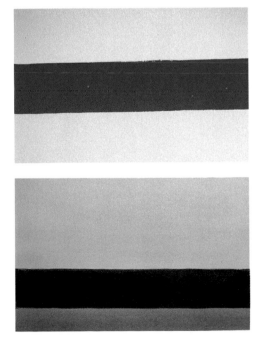

The Bar Theory. As you can see in the top part of this illustration, dividing the paper into equal thirds produces a too-formal, uninteresting division of space. On the other hand, as soon as you break up the space un-equally (the bottom area here) you heighten the interest.

The Action Line

In landscape painting, the horizon line frequently won't be obvious; it may be hidden by hills, trees, or other objects. I have developed a concept I call the *action line* to address this problem. The action line is the line of the dark area silhouetted against the lighter sky. I prefer to use the term "action line" rather than "silhouette line" because "action" connotes a feeling and the sense of something going on.

The action line is particularly useful in painting backlit subjects where color is less important and you need an interesting silhouette to make your painting succeed. Action lines usually follow the landscape as we normally see it, but the action line may be upside down (see example, page 76).

Learning to see and use action lines comes with practice. Try diagramming some action lines based on reference photos and slides you already have, translating them into quick watercolor sketches to see how they work.

Scenes that illustrate the bar theory and action line, such as this one, occur frequently in nature. The line of trees obscures the horizon, so you would need to plan an action line before painting this scene. You don't need to change the basic structure of the bars, however. The sky would be light, the trees a dark value, and the ground a middle value.

**Dunes Sunset
(14x10).** *Here's a painting of a similar subject that demonstrates the bar theory and action line.*

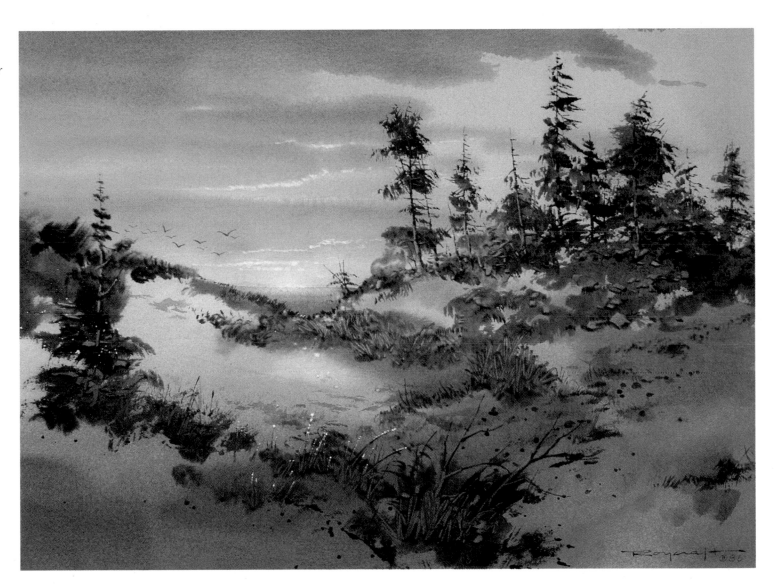

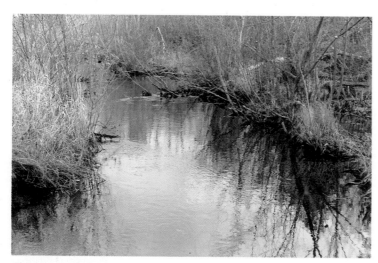

I based "Coming In" on this reference photo. Compare it closely with the action line in the painting to see how this worked.

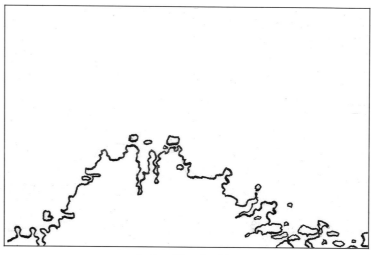

Action Line for "Coming In." This composition was based on the upside-down action line you see here. I eliminated the top action line because the duck is the focal point. The action line is the reflected silhouette of the sky and trees in the water.

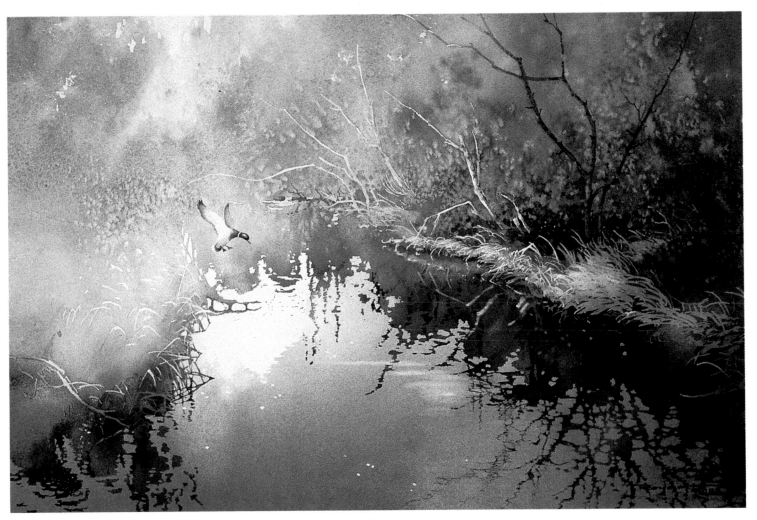

Coming In (21x14). *I translated my upside-down action line and reflections by putting masking on the action line to form hard edges. This is also a good example of how an action line helps when you work with backlighting. Because I had a strong silhouette I could use the glow caused by the backlighting to reduce the foliage to soft edges, offering a nice contrast and the illusion of depth behind the duck.*

Painting with a Pencil

Sketching—"painting with a pencil"—lays the foundation for painting. You need a sketchbook. Always carry it and a soft pencil (4B to 6B) with you to record all the pertinent facts regarding subjects that attract you. But include only what is important. You may also occasionally need a paper stump (tortillon) to soften an area for an effect similar to a wash in watercolor—when drawing clouds, for example. A felt-tip pen is another excellent tool for sketching.

Carefully (and lightly) note the proportions of the subject on the paper until all the shapes are in place. You need make only a few simple pencil strokes to portray almost any subject. Sketch directly, with no preliminary penciling, to develop a fresh, spontaneous technique.

Next, add the correct value to each segment. You can darken the value and show more intricate patterns with crosshatching. Don't use an eraser at this stage or you'll lose the freshness of your sketch.

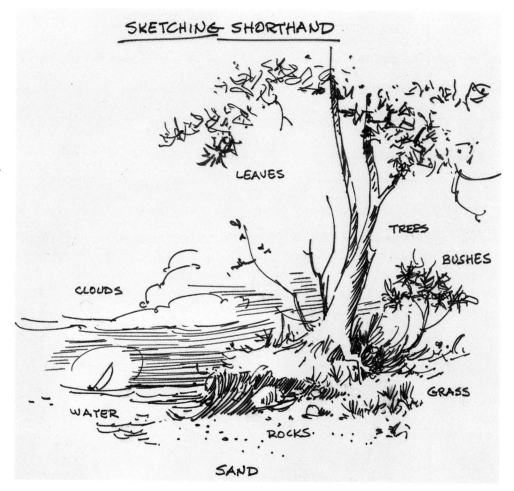

Sketching Shorthand. I've developed my own shorthand to save me time in sketching outdoors. For example, grass, flowers, bushes, trees, and leaves grow in a fan-shaped pattern. By repeating these patterns you can create a mass, such as a tree. Other symbols that I use are illustrated here; you'll develop your own in time.

78

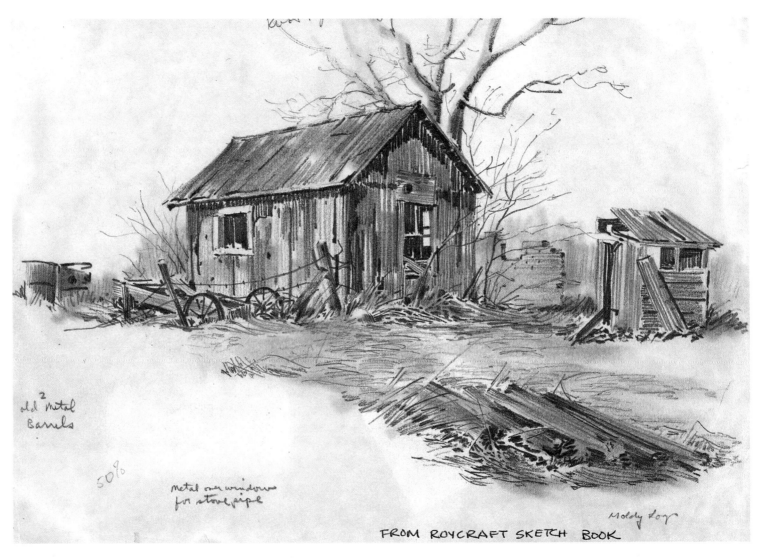

old 2 Metal
Barrels

50%

Metal over windows
for stove pipe

Moldy Log

FROM ROYCRAFT SKETCH BOOK

Sketch everything. The more you learn about nature, the better your paintings will be. Notice how I've used pencil lines here to suggest textures and values. I also made notes to remind me of special points: the log is moldy, the two barrels are metal, and there's metal over the windows for a stove pipe.

Sketching with a Camera

For years I filled notebook after notebook with pencil sketches of things that interested me: old barns, gates and fence posts, oddly shaped trees, weed pods, old boats, people, and the like. Gradually I replaced the sketchbook with a camera, because it allowed me to cover much more territory in less time. I now take hundreds of color photos year-round, at all times of the day, and in all weather conditions. I file them in metal cardfile cases according to subject matter so I can find what I want when I need it. A word of caution: Never use another photographer's work. You won't have felt the excitement that caused the photo to be taken in the first place; the experience will be secondhand.

The camera is a good tool for recording facts relating to the construction, proportions, and to some extent, the colors of objects. The disadvantage to using a photo, however, is that it lacks presence. Only the artist can give that to the subject in a painting or sketch. I go out in the rain, fog, and snow to record the feelings the different weather patterns evoke in me. As an artist you must experience these happenings firsthand; the photos you take are only a reminder of the events you'll later reinterpret in a painting.

I generally use four or five photos to furnish the material I need to compose one painting, drawing on the photos in my files. After each expedition, I label all photos or slides, noting the main reason for taking the picture. Then I file them alphabetically according to type. For example, an entry under "Trees" can be further broken down into "Species," or "Time of Year" (including "Snow-laden"), or "Texture Ideas for Leaf Effects."

Let's look at how one photo might be filed. This photo could be filed under "Trees," "Leaf Texture," or "Summer." To capture both the ideas of summer and leaf texture, I'd file this one under "Summer Texture."

This photo has potential, but the clump of dead trees will have to be enlarged to form a center of interest. In fact, that's what I did when I used this photo as the basis for "Turning Tamaracks."

Turning Tamaracks (14x21). *The tamarack is a cone-bearing member of the pine family that loses its needles in the winter. There is, however, a week or so in November when the needles turn from green to yellow, and the tree has a silhouette that can't be seen at any other time of the year. Compare the painting to its reference photo. Do you see how I've developed the action line here? As I look at the skyline, the holes (negative spaces) between the bare branches create interesting patterns of light and dark.*

A Photo Expedition

Let's take a photo trip together, and you'll see what I look for on a typical expedition. First I look for interesting silhouettes to interpret as action lines. The shapes of treetops against the sky, and buildings with interesting roof profiles or ornate accessories are good subjects. These recognizable shapes can then be used to identify the subject matter in an otherwise abstract composition.

The abstract shapes and forms of nature produce interesting value patterns: for example, patches of snow against the woods, the glare of sun on the sand dunes creating deep shadows, and the reflections of light and shadow on a creek or river. These shapes and forms are what composition is all about—the glue that holds the details together.

I also collect photos that depict atmospheric conditions such as fog, mist, rain, snow, sunrises, and sunsets. I try to capture special light conditions and shadow patterns, even reflections. Photos like these

Here's a building that will give a painting a good action line.

This photo has a good pattern and attractive reflections, but it lacks subject matter—a focal point—to bring it off. Give a lot of thought to the subject you're adding to a painting. It should not only be appropriate to the setting but should give it meaning; often I find I need to put in a person to give my work a human element.

This photo of cloud formations will help when I'm painting clouds. Note how the clouds reveal the perspective of the sky (larger in the foreground and smaller in the distance).

help me to remember the exhilarating sensations I experienced when I was out there.

As you can see by the comments accompanying the photos on these pages, I rarely shoot the perfect photo to make a painting from. Transforming a pretty photo into a painting requires exaggerating, changing colors, developing a focal point, strengthening certain values, eliminating certain elements, and so on. You can never *copy* a photo and expect to get a good painting. Don't be afraid to use your subject material in every creative way possible. As an exercise, take one of your own snapshots of a favorite scene and rearrange the components—their sizes, positions, tonal values, or perspective—to make a better composition. You can even create several compositions from the same snapshot, each telling a different story through a shift in emphasis.

This scene has a rather nice action line and a potentially interesting subject, but nothing dominates. I can't use it as is, so I'll have to think up a focal point for it.

This is a poor subject for a painting because there's no light and dark pattern here at all. To use this photo for a painting, I'll have to invent a pattern. I can put one in when I do my thumbnail.

This subject is interesting, but the picture is not well-balanced. The chimney conflicts with the light tower. I will have to play one of them down— or better still, eliminate one.

Here's a photo of a very similar lighthouse, but in this photo the chimney is concealed behind the tree foliage. This not only has a good composition but also an excellent action line.

CREATIVE COMPOSITION

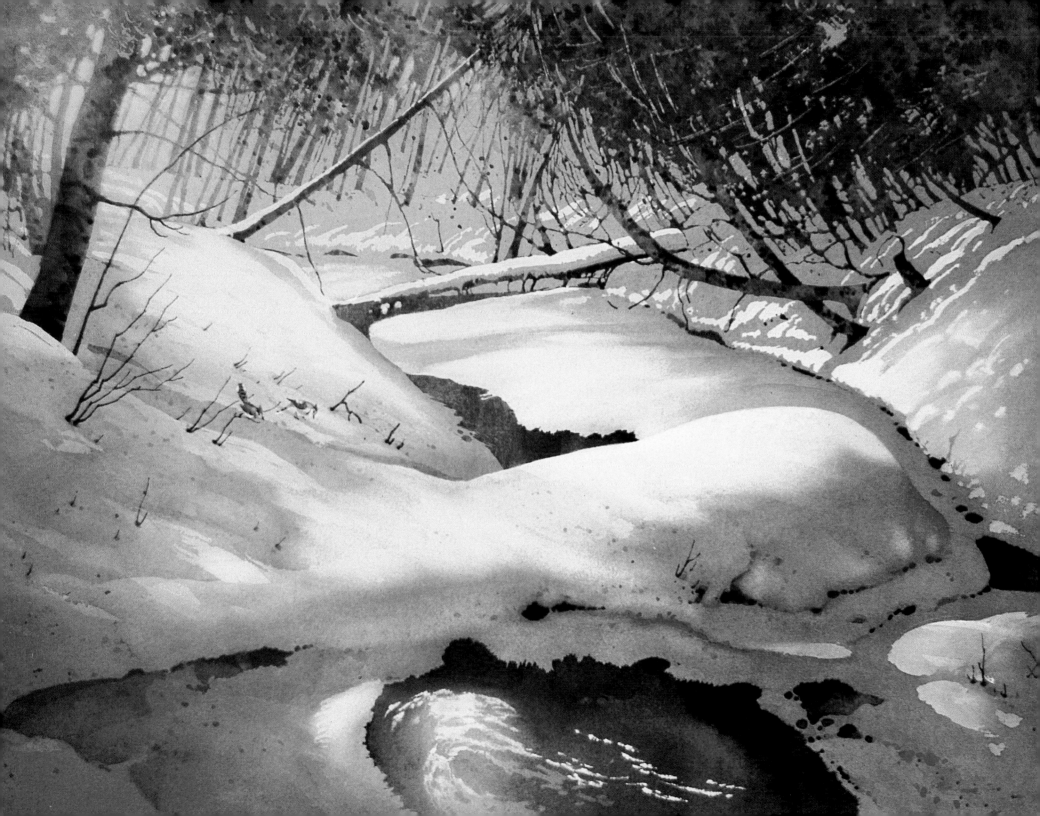

Elements of a Good Painting

A creative idea starts out small, just like a seed. And like a seed it must be planted and nurtured before it begins to grow. Therefore you must plan each painting first—establishing the placement of values and arranging a good composition.

Composition is the artistic arrangement of form and values in a painting. The pleasing relationships between the various components around a center of interest is what makes for a successful painting. You can define your center of interest by its careful placement within the picture, by placing the greatest contrast of values and color there, or by the direction of line of the other elements in the picture. Rhythm also helps support the center of interest and gives your painting vitality. This is the movement created by action or direction of line, leading the eye through the composition.

The way you position or design the main elements of your picture to best tell the story is another im-

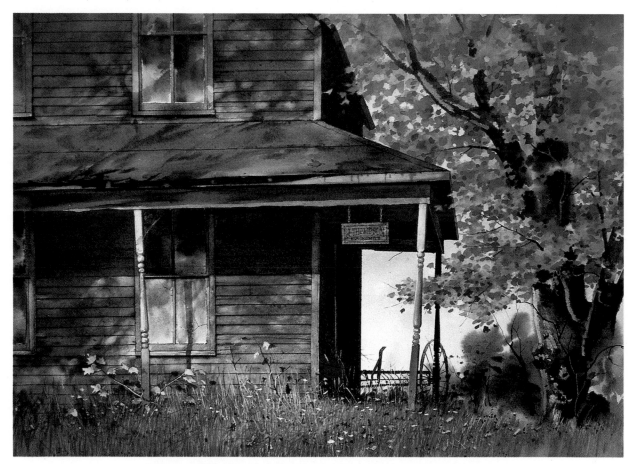

J. Thompson Blacksmith (28x21). *I used a composition based on rectangles for this painting of an old house in Thompsonville. When I was almost finished, I decided it needed a small sign hanging from the porch to humanize it. I made up a name and occupation that seemed appropriate for the time and place. The first time it was exhibited it was bought by a party whose father's name was J. Thompson— and he had been a blacksmith!*

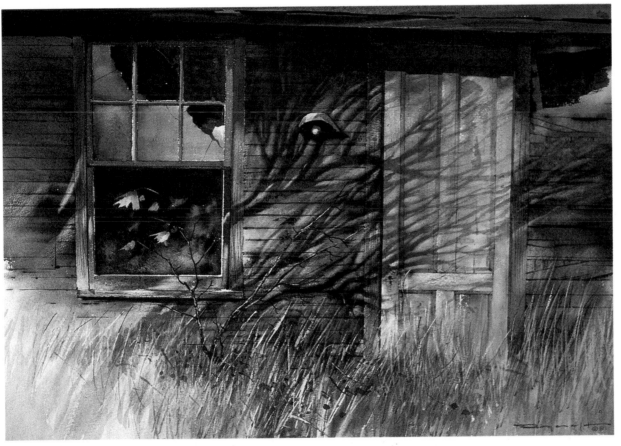

Shadows on the Blue Door (29x21). *This is the back door of the "J. Thompson Blacksmith" house. The predominantly rectangular composition is broken up by the diagonal shadows from a nearby tree. This provides interest and gradation of values otherwise lacking.*

portant part of composition. An artistic balance of these elements creates a harmony that keeps your picture from falling apart.

A horizon line may be necessary to keep the various elements of your picture in perspective. Usually, the horizon line should not be in the vertical center of picture. Establish it either above or below, depending on what portion of your picture carries the dominant theme.

Abstract patterns are another important part of composition. They fall into two principal categories: *geometric* or *free-form*. Geometric (or inorganic) patterns usually include architectural subjects such as buildings and other man-made structures that contain geometric forms—squares, rectangles, triangles, circles, or combinations of these forms. Free-form (or organic) patterns, on the other hand, are associated with nature, and usually represent clouds, trees, hills, streams, and fields. Their general feeling is softer in character than geometric forms.

Designing a Composition

I draw the elements of a picture from my sketchbook or personal photo file. A word of caution: Don't try to fake subject matter, even though you can create atmosphere that didn't exist in the photographed scene. If you combine two or more sketches or photos (or combinations of sketches and photos) into a single picture, be sure they are all related in terms of perspective, light source, and natural habitation. Don't try to mix a fall foliage scene with one of snow, for example.

Once I've chosen my reference materials I make a series of thumbnails— small compositional sketches—to determine my value patterns. I try various horizon lines, focal points, lighting effects, and arrangements of elements until I find the combination that suits the situation best. Do several thumbnails of each subject; if you stop with just one, you might miss an even better idea! Each thumbnail should

I was attracted to this scene by the interesting action line of the building against the sky. You can clearly see how the three-bar theory applies in the accompanying thumbnail.

The action line here has a lacy appearance; you can see this especially clearly in the thumbnail. But notice how the gaps between the trees have been simplified, rather than rendered literally, to improve the composition. This accentuates the lacy quality that attracted me in the first place.

There's a good tonal pattern here, a good three-value (light, medium, and dark) composition. But the foreground will need simplifying, which has been done in the thumbnail.

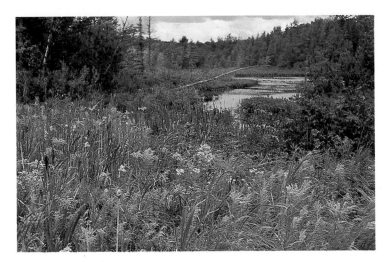

I like the wildflowers in the foreground, but the background needs development. I worked out the problem in my thumbnail; the three values are more distinctly defined now.

take only a few seconds to draw. Keep them small, 2x3, to eliminate detail. In fact, they can be almost abstract, since you want to concentrate primarily on getting the distribution of the values right. Once you've settled on their placement, you want them fixed clearly in your mind before you begin to paint. After I've selected the final black-and-white thumbnail, I sometimes do one in color to establish the palette I'll use.

I enlarge the compositional thumbnail to fit the full size of the stretched watercolor paper already taped to my board. I pencil in precisely all the necessary details I want to include. Because thumbnail sketches are very spontaneous, you may have difficulty enlarging them accurately and retaining the correct shapes. You can use mechanical devices, such as a Pantograph or opaque projector, or try manual transfer methods using a grid or scaling on the diagonal.

Here's the thumbnail I used to set the values and composi-tion for "Spring Delivery."

Spring Delivery (29x21). *And here's the result.*

Compare the areas I masked with the value pattern of my thumbnail smudge.

I made several thumbnails to determine the composition for "Yesterday's News"; the bottom one was the one I used.

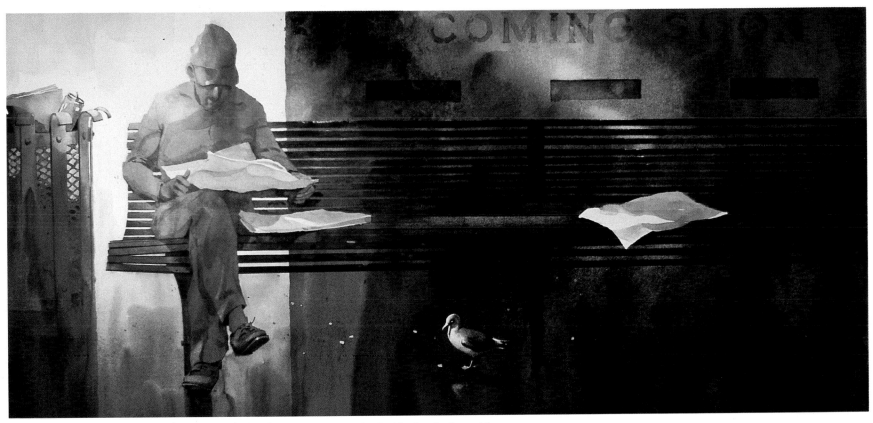

Yesterday's News (29x14). *Now compare the finished painting with each of the previous stages.*

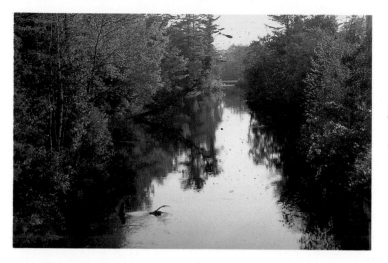

This is the reference photo I used for "Butterfly on the Betsie."

Then I worked up the values and composition in this thumbnail.

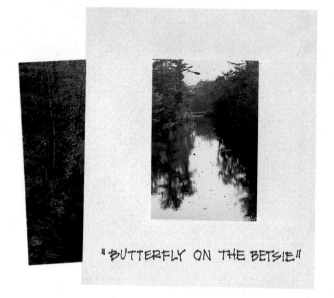

"BUTTERFLY ON THE BETSIE"

I cropped it with this mat to get a good composition.

I followed my thumb-nail with my initial masking.

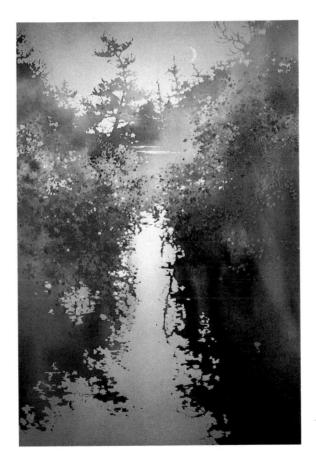

Butterfly on the Betsie (14x21).

Inspiration from Smudges and Blotches

Smudges are small (3x2) abstract value patterns that I use for creative compositions. I rub a soft pencil lead or piece of charcoal on a piece of paper, then soften the marks with a paper stump. I create lighter areas with a kneaded eraser.

I look for interesting value patterns that are in the correct proportion to each other and also apply the bar theory to determine what kind of scene a smudge suggests. I look for a light value for a sky, a medium value for the land, and dark for vegetation for a fall landscape; or I may find a winter scene if the smudge suggests a light band for the land, a dark one for vegetation, and a medium one for the sky. Sometimes I'll find more than one composition from a single smudge. *Winter* and *The Last of Jefferson Davis* were both inspired by the same smudge—after I finished *Winter*, I turned the smudge upside down and found *Jefferson Davis*.

Make color blotches by dropping or spattering colors from a loaded brush onto a piece of paper and letting them run together. (This is essentially the same way I mix colors in a painting, see pages 30-35.) Sometimes I lighten the values by letting excess color run off the paper while it's still wet.

How do you turn the dried color blotch into a composition? Cut a small window or viewfinder (about 1-1/2 x 2-1/2 inches) in a piece of white paper or mat board. Move this frame around over a blotch, framing it several different ways. When you find an interesting pattern or color sequence, mark it by outlining the window with pencil. You may find several compositions in a single set of blotches. But don't expect the blotches to represent an actual scene. Instead let them set the mood or color scheme for a painting.

I made this smudge with a 6B (very soft) pencil and a stump.

Then I placed a small viewfinder around the smudge in various positions, looking for an attractive pattern for a painting.

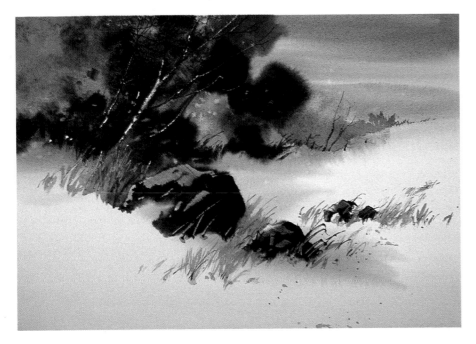

Winter (14x10). *Following the bar theory, I worked the smudge into a winter scene, since it suggested a sky area darker than the land area. The darks suggested winter foliage to me, and the darkest spots could be large rocks in the snow.*

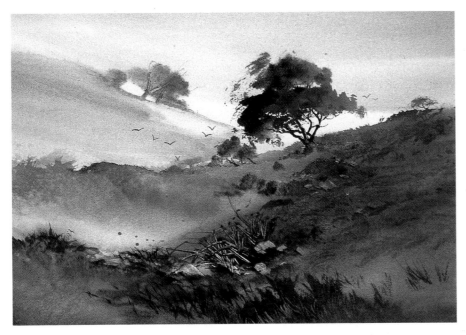

The Last of Jefferson Davis (14x10). *The same smudge turned upside down suggested a late summer composition. The pencil strokes now suggested rolling hills, and the dark shapes looked like the old apple trees in my front yard. ("Jefferson Davis" is one of the last apple trees in my area, dating from when our yard was part of an apple orchard.)*

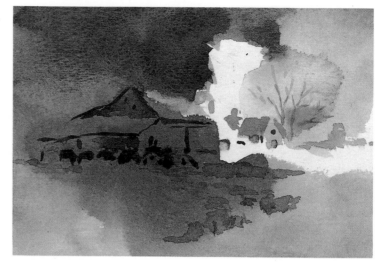

Here's an exercise to help you learn to draw inspiration from a color blotch. Study the example here, then try your own small watercolor sketches. Create an attractive abstract arrangement of colors.

Find a subject you like—perhaps a sketch from your sketchbook or a quick thumbnail sketch based on a reference photo.

Position the sketch over the color blotch as shown here.

The colors in this blotch suggested a mood that intrigued me. I found a photo of a country lane in my reference file that seemed to fit it perfectly.

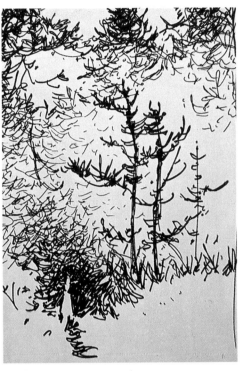

First I made a sketch to determine what ingredients to include in my composition. I sketched in the action line and added pine trees to the foreground. The lane in the photo leads to a cherry orchard, so I added a single migrant worker to be the center of interest.

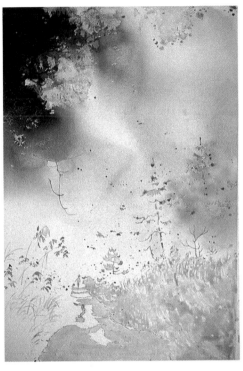

Masking off the foreground, the migrant worker, and a few leaves that were to be struck by filtered light was the next step. Payne's gray and ultramarine blue were brushed into the upper left corner and misted to provide that filtered effect. Then I added Antwerp blue and aureolin yellow to complete the background.

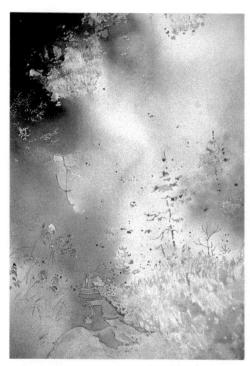

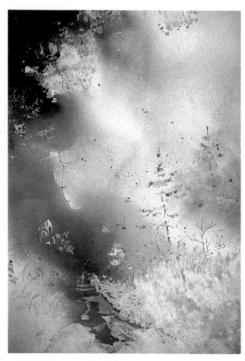

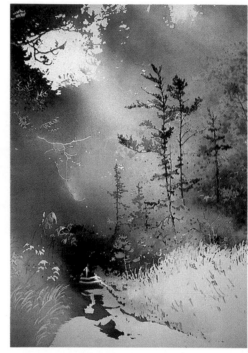

To build up the background, I poured one color at a time. I sprayed after each pouring, letting the water jet spread the paint where I wanted it and using it to lighten the paint where necessary.

Brown madder, Winsor red, and aureolin yellow were added to strengthen the colors.

After the paint dried, I removed all the Maskoid except for that covering the man. I painted in the foreground pine trees with a no. 5 round brush. Next I poured a mixture of cobalt blue, Antwerp blue, and ultramarine blue from my palette as a single wash.

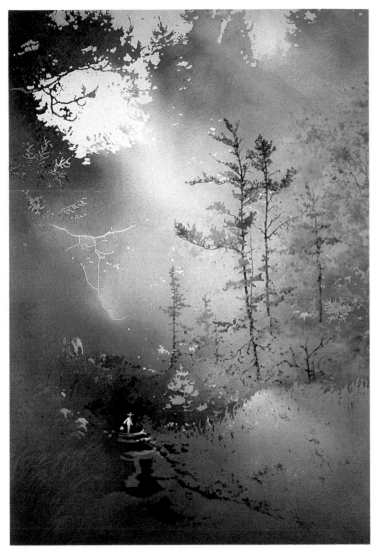

Detail of "Country Lane." My goal was to create a negative shape with a little color on it—just a silhouetted form illuminated from above.

Country Lane (14x21). *I continued pouring layers of color until I got the effect I wanted to define the light source. Compare the color blotch with the finished painting it inspired to see how they are similar yet different.*

WORKING IT OUT

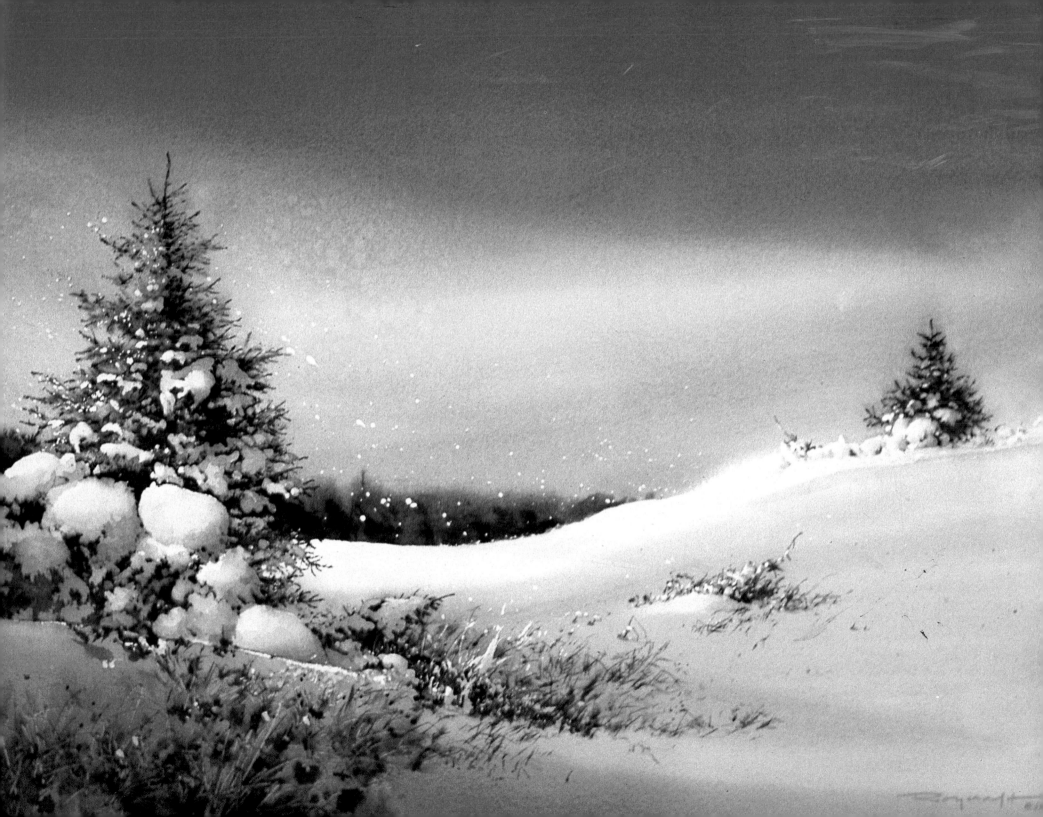

A Guided Tour of the Thought Process

To help you follow the thought process I use in my painting, I'll take you step by step through the development of *Gertie's Creek*.

Out of a whole roll of pictures, I selected the photo shown here to interpret into a full-sheet painting because it had good horizontal patterns of black and white. I used thumbnail sketches to design the composition, altering the real scene to fit my needs. The foreground part of the creek was expanded to produce a horizontal bar in addition to the natural one created by the distant woods so that that direction would be dominant. I enlarged and simplified the foreground trees to keep the horizontal action from running off the sides of the paper. For balance, the distant part of the creek was made part of the vertical composition on the painting's left side. I simplified the fallen logs across the creek, which serve as a bridge uniting the left and right snow masses.

The first test of my composition comes when I apply the gray Maskoid to all light and medium value areas. Now the pattern appears, although in negative. At this point, I decided to add the dried beech leaves and highlights on the water to break up some of the large masses.

Before I can begin texturing the darks, my first application of paint, I must select the time of day, direction of the light source, mood, color scheme, and weather conditions. This is the last time I'll refer to the reference photo. The first paint that touches the paper sets the tone for what follows. Go where the painting takes you, or you'll be fighting the elements to the end—and the painting will *not* be a success. This is why initial planning is so important.

Because I have already decided that a horizontal pattern will dominate the composition, I want the light source to come from the left to produce horizontal shadows. The woods and their reflections in the water will be predominantly warm,

This photo of Gertie's Creek, just outside Traverse City, Michigan, inspired my painting.

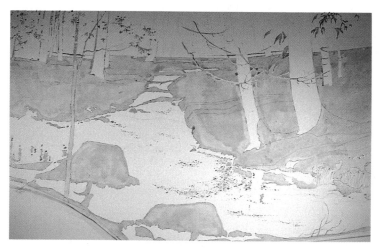

After working out a detailed drawing, I applied Maskoid to all light or white areas. I used scraps of mat board fastened with masking tape to mask off the large snow area at the bottom—it's more effective and economical than brushing on large areas of Maskoid. Allowing some Maskoid to run along the edges of the tape around the board will keep the color from seeping underneath.

and I have to exaggerate the hue to compensate for the glazing that will come later.

The woods should have texture to suggest the thousands of divisions of space formed by leaves, branches, boughs, and so forth. As I'm applying the texturing I visualize the filtration of light through the trees in the upper left part of the painting. The colors of the woods must get cooler as they recede from the light source so the woods won't appear flat.

This texturing is the part that only God can create. I only react to what I see happening. By alternately spraying beads of water from a spray bottle and spattering or throwing paint from a brush, the paint and water create patterns and textures I couldn't possibly conceive. As I tell my students, "God paints the picture; I only hold the brush!" Texturing is the most exciting part of painting because it is the most uncontrolled.

The water in the painting should look wet and reflective. It will consist of the same colors, only darker in value, as the textured area

I textured the trees by spraying and spattering paint on them. I kept the board flat during texturing because I wanted the colors and the water to interact.

above it. To avoid monotony I vary the colors and textures within the reflections. When I feel that the woods and water relate to each other in a unified way, I let the paint dry and remove the Maskoid except over the water highlights. I have purposely avoided the color and character of the water in the photograph. After all, I don't paint the real world; rather, I paint a sort of fantasy scene that allows me to be freer in my conceptions and gives me the chance to express a unique happening.

A little warm color on the otherwise pristine snow will take the curse off the plainness. First I pour Winsor yellow from the upper left side of the paper. Next, Winsor red is applied from a point on the paper slightly below where I poured the yellow. I mix the blues on the palette; each pouring of blue requires a different mixture so that the color of the snow will vary from one side to the other. If the snow gets too blue, red and yellow glazes poured over the top will gray it down.

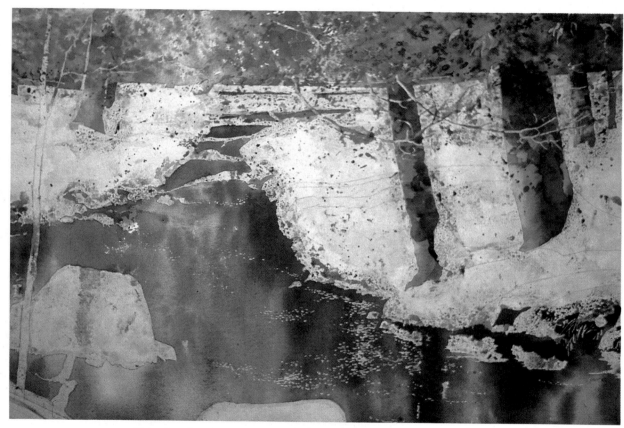

To paint the water portion in this stage, I propped up the back of the board with two wooden blocks (one and two inches thick). This gives me three angles of slope from which to choose. I usually put them both together to get the steepest slope so the water will run when painted in.

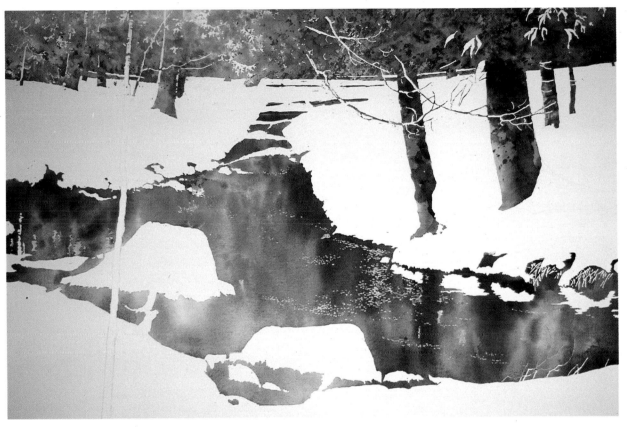

The painting with the first Maskoid removed.

I felt pretty good about this painting after I'd poured in the snow, so I removed all the Maskoid except for the sparkle on the water. Some areas still needed refining, though the three values had been established. The basic refinements—softening edges, bringing out details and strengthening some shadows—require patience but really bring the painting together.

After setting *Gertie's Creek* aside over the weekend, I decided to simplify the shadow area in the center of the painting. A little gentle scrubbing with a toothbrush removed the unwanted color. Then with a squirt of the spray bottle I cleaned up the residue.

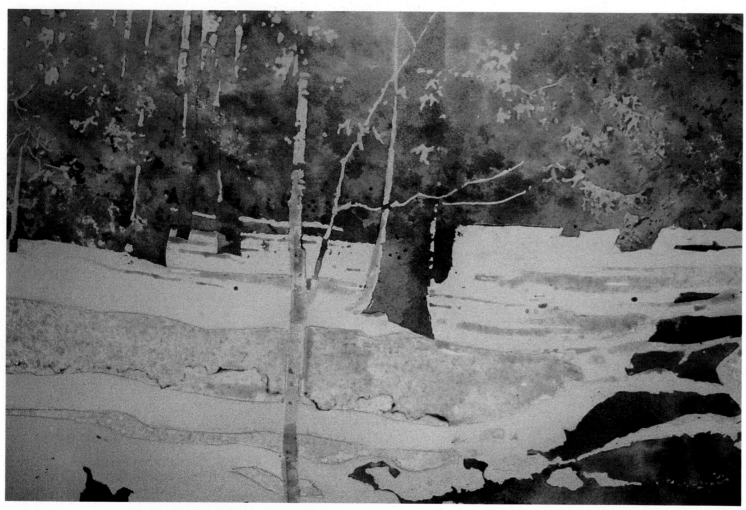

*The highlights on the snow are masked
again; these highlights will further emphasize
the horizontal pattern.*

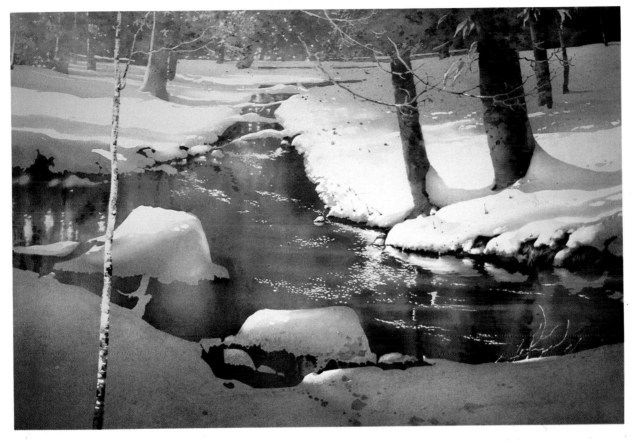

Gertie's Creek (29x21). *It's important to know how much detailing is enough. Here I've added a lot of detail to certain areas in the foreground to serve as a focal point for the painting. The left side is much less finished in order to give that area some mystery. Adding detail to the entire painting would leave nothing to the imagination of the viewer. Some mystery helps draw the viewer back to the painting again and again.*

Same Scene, Another Approach: Gertie's Creek, Too

Here's a second, more atmospheric interpretation of the same scene to show what can be done by experimenting with color for various effects. In this version I selected a color scheme composed of a cool blue, a cool red, and the violet that resulted from mixing the two. This set the tone for the entire painting.

To paint the reflective water surface, I propped the top of my board to a height of about three or four inches with wooden blocks. I sprayed the paper with water and followed immediately with dabs of strong blue color, trying to get the proper value the first time around. The excess water ran down the slanted surface and off the bottom of the paper, where I mopped it up with a sponge. It's best to get the value right the first time, but if a color dries too light, I repeat the misting and paint application until I get it right. Then I let it dry thoroughly and remove the masking.

Here I began with the photo I'd already used for "Gertie's Creek" (see page 106), but this time I used color to create an entirely different mood. I applied Maskoid to my detailed drawing. If you compare the composition and the placement of masking in this painting to the same stage of "Gertie's Creek," you'll see some distinct differences in my approach.

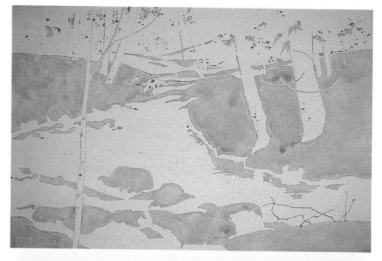

I started with cobalt blue in the upper right corner of the painting, misting the area and then spattering the paint into it.

112

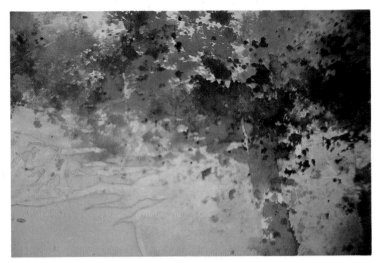

Gradually I worked to the left, introducing Winsor red. As the paint hit the partially wet paper, it followed the wet portion, producing intricate patterns and textures of woods. I kept applying paint and misting with water until the proper texture and value were obtained. The accidental process of texturing imitates nature better than anything I could consciously design.

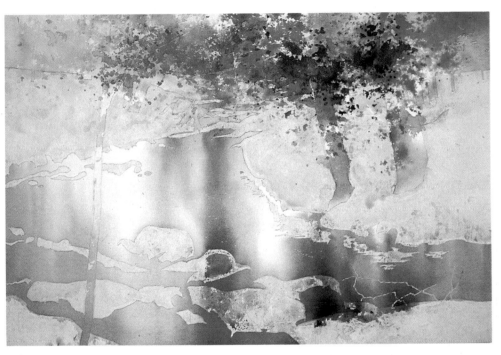

Next I pour on the colors of the tree's reflections in the water.

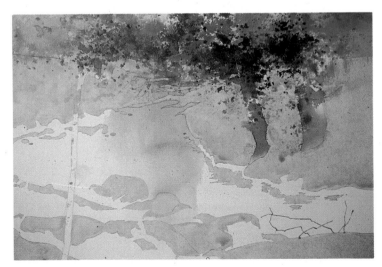

Here's the whole painting again, to put the last three steps into perspective.

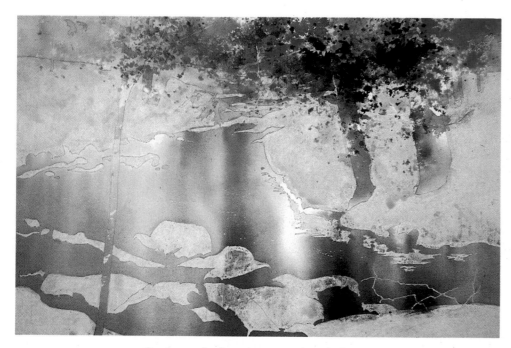

One layer of red was not enough to darken it, so I add another.

The first layer of Maskoid is removed, and I reapply a fresh coat to selected highlight areas. The next pouring will gently tone the unmasked areas.

114

I pour blue paint into the lower right. When I'm done, I lighten the tree shadows.

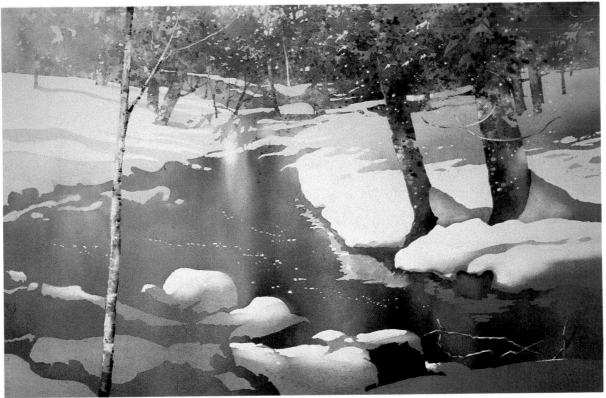

Gertie's Creek, Too (21x14). *When I remove the final masking, I'm finished. I've used more exotic colors in this half-sheet painting than in "Gertie's Creek," and the process here is simpler.*

Layering Cool Over Warm

There's an old farmhouse with several outbuildings in the woods behind my house that've been vacant since the twenties. One day I thought, if I were to put a light in the window and add some smoke in the chimney, these old buildings would look lived in. So I created a winter evening scene. *Dinner Time* reveals the powerful variety of color you can achieve by masking your whites, pouring color over all other areas, then lifting the Maskoid and pouring fresh color—in this case cool blues and red purples—for an entirely different and striking mood.

I based the drawing on five slides I'd taken years ago. The tree shapes were so complex that I projected the slides so I could trace and capture those shapes accurately. As a result I had more detail in the tree than usual.

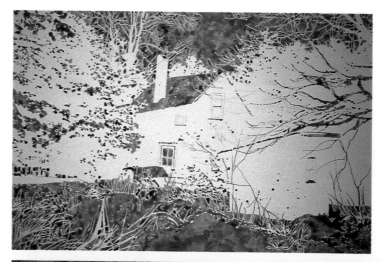

I began by applying the Maskoid. Notice that, in addition to applying and spattering it as I usually do, I've worked around all the little grasses and weeds.

Then I threw on a rainbow of colors, blowing each one dry before going on to the next.

116

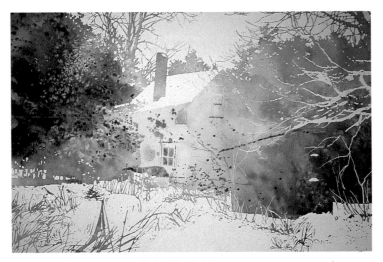

Now that I've removed all the Maskoid except from the areas to be left white in the finished painting, you can see the effect of leaving all the grasses and branches uncovered—there are lots of gradations in their colors.

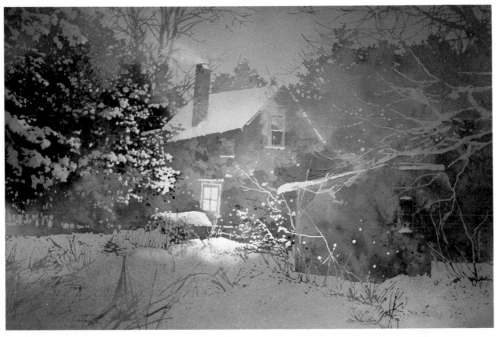

Dinner Time (21x14). *I left the window areas light, then poured blue over everything at the end to unify it. I made this an evening scene because I felt the contrast between the blue and the yellow glow in the window would best convey the mood and atmosphere I wanted. Had I used a yellow and orange glaze instead, the window would never have stood out.*

117

Capturing Nature's Moods

The Platte River has been a favorite with fishermen for as long as I can remember. Wading that stream in search of trout, I feel wonderfully alone and at peace with the world.

As you follow the steps in this demonstration, see how I used the information from the photograph without copying it exactly. Also study what I masked out and how I translated the three values from the photo into my painting. The darks frame the subject matter effectively, and the fallen log gives the painting depth. Think about what adding the fisherman as the center of interest brought to the painting. Would it work as well without him?

Here's my original reference photo.

I masked out all the light and medium value areas.

Next I textured some areas and painted in the darks. I removed all the Maskoid, then remasked the highlights.

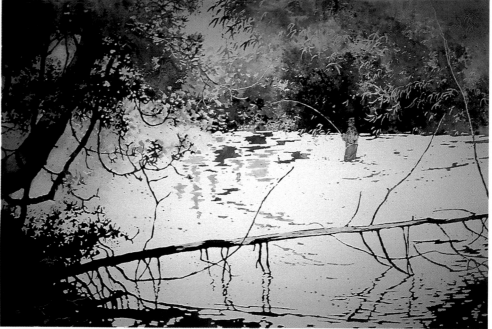

118

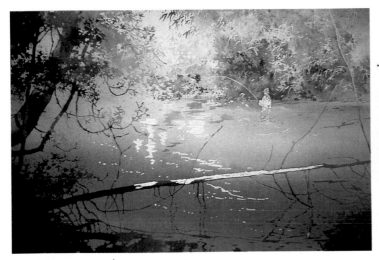

To paint the water's surface, I propped up the top of my board with wooden blocks. I sprayed water on that area of the painting and immediately applied dabs of strong blue color, which I let run down the slanted surface. Using a sponge, I mopped up the excess water that ran off the paper.

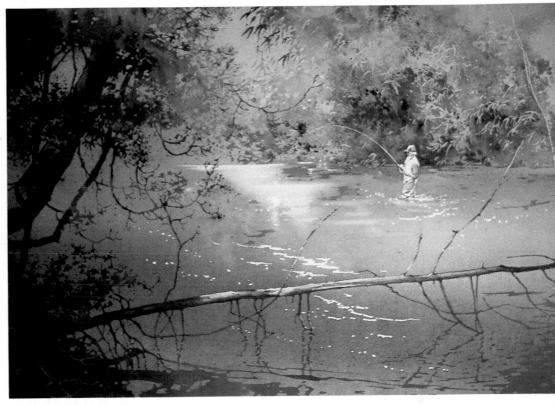

Trout Time (21x14). *The final steps were to remove the masking from the highlights and refine the details. Compare this scene with the original photo. Can you see what impact adding a figure as the center of interest gives your painting?*

Interpreting Weather Through Color

I came upon this scene while skiing cross-country in late March. The early morning sun was extremely bright, and the waters were running. I could feel the warmth of the countryside as the snow slowly began disappearing and tried to envision how I could convey this feeling on paper.

I had taken these two pictures of the scene, but they didn't capture my feelings. The first problem was eliminating all the extraneous and confusing detail. I made a dozen thumbnails before settling on a simple abstract sketch of the composition. I sketched the details directly on the watercolor paper.

The painting wasn't warm enough to capture the mood, so I poured Winsor yellow over the entire painting to unify the colors and add a sunny quality to the scene.

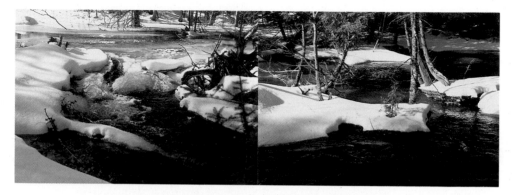

I worked from two photos taped side-by-side for greater breadth of vision.

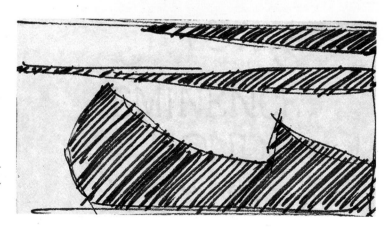

This was the simple, abstract sketch I chose for the composition.

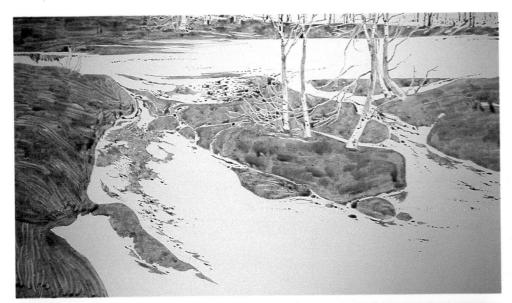

I applied the Maskoid.

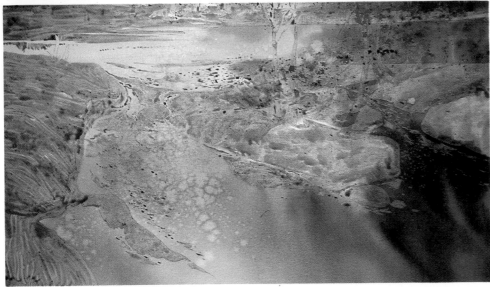

I threw, spattered, and poured the background darks. You can see where I've misted back into the color in the lower left corner of the painting.

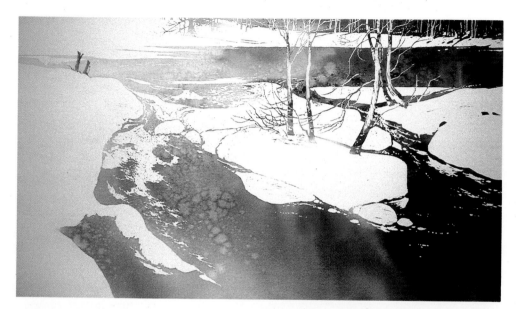

Here I removed the original masking.

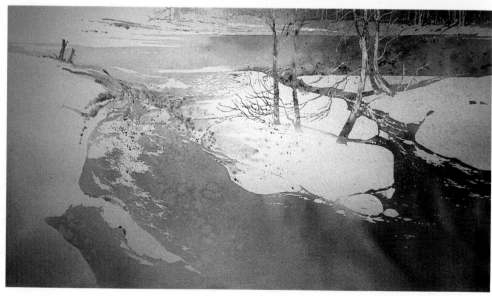

I remasked the highlights on the snow and poured the blues.

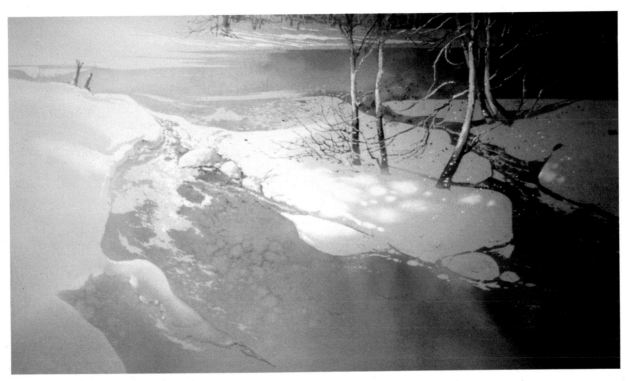

Spring Waters Flow (29x16). *I didn't think the painting looked warm enough so I poured yellow over all of it, which also helped to unify it.*

ARTIST
AT WORK

—

Victorian Roost (14x21). *This old house on Marilla Road is a classic example of the handiwork of carpenters from another era. As the sun came through the trees, throwing dancing shadows on the wall, I imagined the pioneers who once lived there—although the only voices to be heard now are those of the pigeons who roost in the gables.*

I masked off the sky and all the clapboards, leaving only the spaces between them. Then when I applied paint, I painted only the shadows. I designed the cast shadows on the lower part of the house to focus attention on the ornate gable.

I threw in the warm primaries, working toward cooler, grayer colors at the bottom. All the bright colors—yellow, red, and orange— are in the tree where the sun strikes it. The shadows near the bottom of the house, made by mixing the three warm primaries together, are neutral.

I removed the masking, poured the shadows on the lower area, and wiped out the soft highlights on the house.

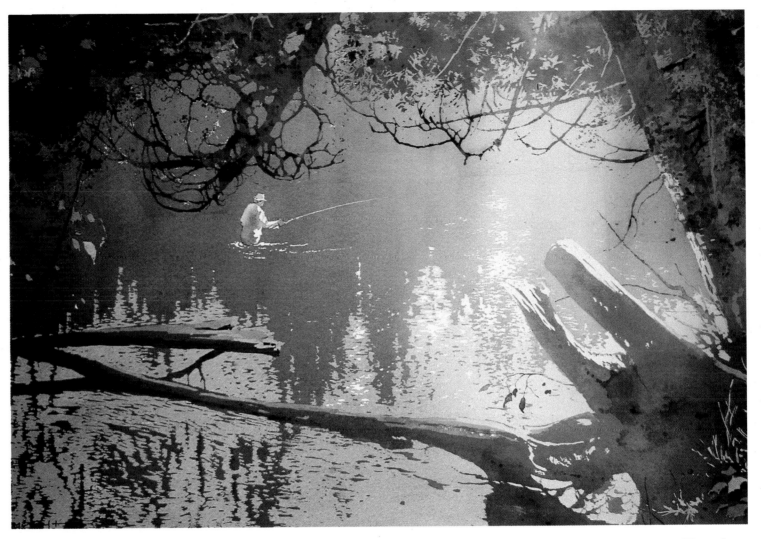

Eternal Hope (25x20). *The Crystal River winds back and forth through cedar lowlands in a pristine area of northern Michigan. The early morning sun cuts through the lingering fog, and eager fishermen are ready with rod and reel for the unsuspecting trout. Hope springs eternal as we wait for that first nibble. I wanted to frame the subject matter with an interesting border that would evoke the feeling of intimacy with nature that every fisherman enjoys. Then to enhance this effect, I subtly changed the colors in the fog to give life to this otherwise dreary scene.*

Sun Streaks on the Platte (14x21). *The action line first caught my attention when I thought about this painting, and I added reflections to accentuate it. Though there are no buildings in this landscape, perspective still played a part in its composition. All directional lines come to a vanishing point at the center of interest, giving depth to the subject matter.*

I masked the sky to form the action line, then the snow and water reflections. Next I painted, threw, and spattered the foliage and let the water flow wet-in-wet with the same colors used above. I removed all the masking and remasked the highlights on the snow and the water before pouring in the water and atmosphere. After I removed the masking, I had only to soften the highlights.

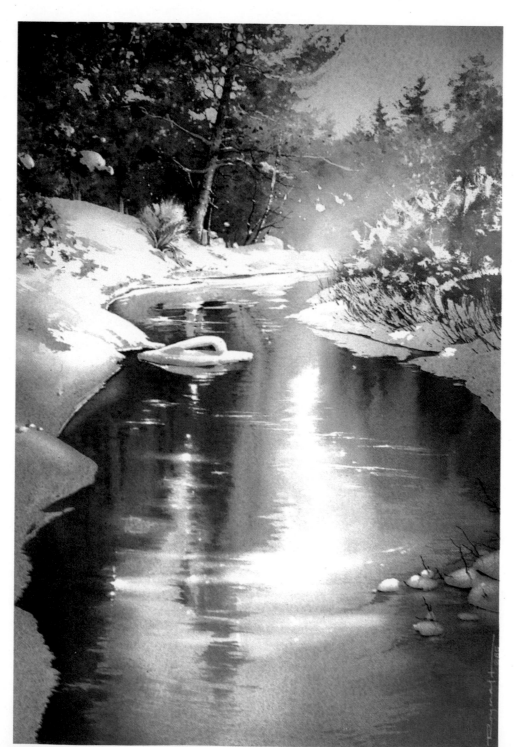

River Reflections (13x21). *All the colors in this painting were mixed on the paper. I controlled the color by varying the intensity of the washes and directing the flow on the tilted board.*

This painting contains every color in the rainbow. For the foliage and reflections, I masked out the lights and sky, then spattered on aureolin yellow, cadmium scarlet, and Antwerp blue—the warm primaries—for texture. I painted the foliage first so I'd know what colors to paint the reflections. To do this, I let the foliage color dry, squirted water on it, and then painted downward from the bottom of the foliage, using the same colors. I dabbed in the colors with a brush, tilting the board so the color would flow down naturally, then mopped off the excess paint. The sky was poured in at the end, using the three cool primaries.

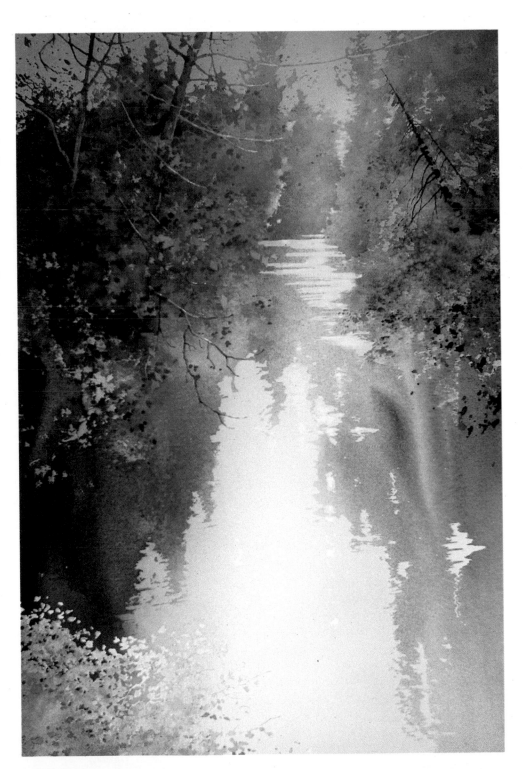

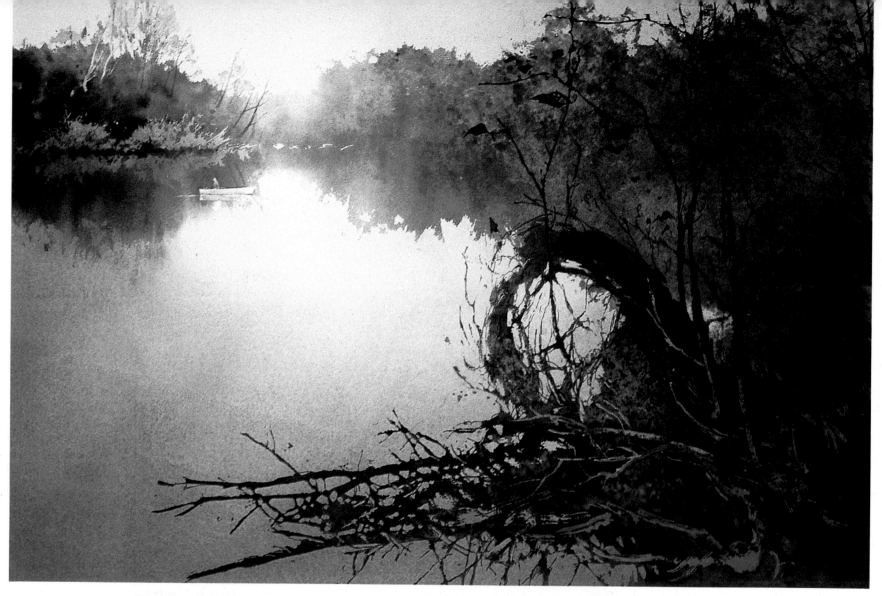

Prime Time (21x14). *Set in a wilderness undisturbed by man for the last hundred years, Otter Creek is probably my favorite area for gathering research material for painting. There you can see beavers at work or hear the loons cry as they dive and skim across the water. Entertainment is abundant, but in this painting I wanted to capture the quiet contrast between tangled brush and placid water.*

I masked off the sky, water and boat, then threw in the warm primaries, starting at the light source and working toward the foreground. After removing the Maskoid, I poured in the cool primaries to create the sky and water. It took several pourings to build up the foreground to the right colors and values. I strengthened the brush in the foreground where it overlaps the background and painted in the fisherman and his boat.

Spring Snow (22x10). *Just when you think spring's come, there's always one last blast of arctic wind that brings a wet snow. The early morning sun hasn't yet begun to melt the cold, bluish snow, but already you can sense the warmth infusing the cold morning air.*

This scene is a composite of two pictures. I moved in the pine tree grouping on the left from about one hundred feet away to replace the scrubby bushes on the spot I wanted to paint. Still, I needed to add something to complete the action line that would be reflected in the creek. In my photo file I found an image of a snow-covered tree that tied both sides of the painting together.

I masked the sky, the water (working around the reflections), and the snow areas. Then I painted and threw in foliage color, working from warm to cool. After I removed the masking, I painted the shadows on the snow. Next I poured atmospheric colors on the sky as well as on the snow and water at the bottom. As a final step I drybrushed in the distant trees that projected into the sky area. (Watercolor West Purchase Award)

131

Forest Floor (21x14). *Spring is a time of renewal, when dried leaves give way everywhere to fresh sprouts of life. Wildflowers and mushrooms seem especially tiny and delicate compared to their surroundings. This is the season to roam the countryside and sketch these fragile friends.*

I masked off the small flowers, leaves, and plants in the foreground. Using direct painting I rendered the large tree, the spruce, and the small trees, then added some spatter in the foreground for texture. Next I painted in the sky area and poured the foreground. After removing the masking, I painted in the detail on the young plants.

Sailing Through the Fog (14x21). *The challenge here was to portray the peaceful but lonely mood evoked as fog blows in over the open seas. The cool colors indicate a melancholy feeling, yet a spark of light on the water lets you know that everything is going to be all right.*

To begin I masked off the sails, the top of the boat, and the highlights on the water. I brushed in the sky and wave action wet-in-wet, using all the blues on my palette. In a case like this, overpainting on the water area (when the washes are dry) must be held to an absolute minimum or it will lose its transparency. I removed the masking and painted in the sails, boat deck, and crew. Finally, I used a razor blade to sharpen the highlights on the water and lifted color as needed to lighten some water areas.

Index

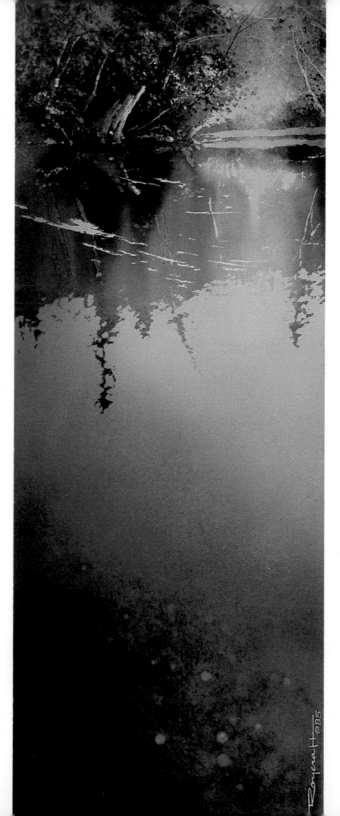